HAUNTED
SOUTHERN TIER

HAUNTED
SOUTHERN TIER

ELIZABETH TUCKER

Published by Haunted America
A Division of The History Press
Charleston, SC 29403
www.historypress.net

All images are by Geoffrey Gould unless otherwise noted.

First published 2011
Second printing 2012
Third printing 2012

Manufactured in the United States

ISBN 978.1.60949.111.6

Library of Congress Cataloging-in-Publication Data
Tucker, Elizabeth, 1948-
Haunted southern tier / Elizabeth Tucker.
p. cm.
ISBN 978-1-60949-111-6
1. Haunted places--New York (State) 2. Ghosts--New York (State) I. Title.
BF1472.U6T79 2011
133.109747--dc23
2011021181

For my husband, Geoffrey Gould,

whose photographs bring out the beauty of the Southern Tier.

CONTENTS

CONTENTS

ACKNOWLEDGEMENTS

I am very grateful for the kind assistance of Josette Berardi and her daughter Nicole Rose, Jaimee Colbert, Eve Daniels, Carol and Alex Fischler, Dennis Frank, Robert Keller, Janet Langlois, Father John Martinichio, Thomas McEnteer, Gerald R. Smith, Susan Strehle, Frank and Shelley Takei, Theresa Wells, Maryanne White and Mason Winfield, all of whom I thank very much. I want to thank all of my wonderful students at Binghamton University, who have told and collected so many fine stories. I also want to thank my editor at The History Press, Whitney Tarella, for all of her support during the process of writing and editing. Warm thanks to all!

INTRODUCTION

A house-proud tycoon who throws bronze bars, a young Mohawk woman who sings after dying in a train wreck and a lady in white who hitchhikes to a prom or wedding she will never attend: these are just a few of the ghosts that haunt New York's Southern Tier. Some of these are ghosts of nineteenth-century settlers who became rich and built mansions; others remind us that Native Americans lived on the land before anyone else arrived. All of them help us understand this historic region of New York, which stands above the Northern Tier of Pennsylvania: Broome, Tioga, Chemung, Steuben, Allegany, Cattaraugus, Chautauqua and Delaware Counties.

It has taken a while for the Southern Tier to become known as a haunted region. Americans' awareness of its ghostlore grew in 1959, when Rod Serling launched his hit television series *The Twilight Zone*. That exciting new show blended science fiction with supernatural and horror legends, suspense and thoughtful consideration of the past. I vividly recall watching *The Twilight Zone* during its first years, when I would sneak into my family's TV room for a break from homework. Some characters—a frightening hitchhiker, a talking doll and a man in search of his boyhood self on a carousel—amazed and delighted me. I had no idea then that these characters came from the not-very-famous city of Binghamton, which would become my home when I applied for a job at Binghamton University. Now I am beginning my thirty-fourth year there as an English professor specializing in folklore. My ghost story files have become so enormous that they spill out onto the floor, threatening to cover the rug. It is time to open my file cabinet and share the Southern Tier's haunted history.

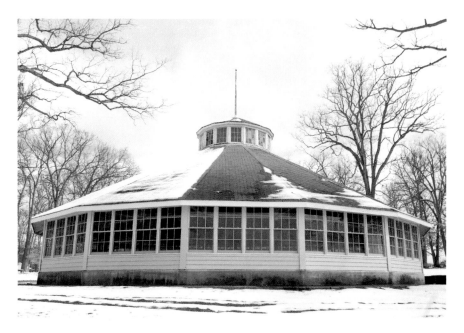

Carousel building in Binghamton's Recreation Park, where people claim to have seen Rod Serling's ghost.

I am not the first to describe the ghostlore of this region. Louis C. Jones included a few Southern Tier stories in his wonderful book *Things That Go Bump in the Night* (1959). DuWayne Leslie Bowen wrote two significant books about Seneca ghost stories, *One More Story* (1991) and *A Few More Stories* (2000). Mason Winfield's *Shadows of the Western Door* (1997) includes fascinating material from the western part of the Southern Tier, as does his documentary film *Phantom Tour: The Thirteen Most Haunted Places in Western New York* (2003), co-written with Terry Fisher. Recently, paranormal investigator Dwayne Claud published a book titled *Ghosts of the Southern Tier, NY* (2010), which takes the reader on a ghost-hunting journey from one Southern Tier county to the next. Interest in Southern Tier ghostlore is rising, and there is plenty of material to go around.

Throughout this book I use the terms "ghost" and "spirit" interchangeably, but I find "spirit" especially appropriate for the lively ghosts of the Southern Tier. Among the various meanings of this term are the soul, an animating force and a lively, courageous attitude. Based on the Latin verb *spirare* ("breathe"), the word "spirit" suggests energy and depth of feeling. Southern Tier spirits are not pale shades or retiring

wraiths. Expressing the life force they once possessed, these spirits of the dead have come back for good reasons. Deciphering those reasons has kept me and my students at Binghamton University happily occupied.

Researching ghost stories at colleges around the United States has shown me the connections between community spirit, ghost stories and local or regional history. Most of the stories I've collected have been told as true, reflecting personal experiences that are important to their tellers. Beyond that personal meaning stand layers of history. Residents of the Southern Tier tell supernatural narratives about Native Americans, Spiritualists and nineteenth-century industrialists. They talk about haunted churches, mansions, large and small homes, colleges, hospitals and roadways. These ghost stories express narrators' pride in their hometowns and colleges, awareness of conflicts and curiosity about a mystery that concerns us all: the borderline between life and death.

Why do ghosts come back to visit the living? In *Things That Go Bump in the Night* (1959), Louis C. Jones gives five reasons: "to re-enact their own deaths; to complete unfinished business; to re-engage in what were their normal pursuits when they were alive; to protest or punish; or, finally, to warn, console, inform, guard, or reward the living."[1] In my own research across the United States, I have found that ghosts' prime motivations for haunting are to complete unfinished business and to console relatives and friends. Like those of us who keep busy living our lives, ghosts have much to do and want to stay close to the people they love.

This book does not attempt to cover all Southern Tier ghostlore, but it offers examples of the region's most important kinds of stories. You will notice an emphasis on stories of the eastern part of the Southern Tier. I know that part of the Tier best, having lived in the bowl-shaped valley of the Susquehanna and Chenango Rivers for more than thirty years. There have, however, been opportunities to get to know other parts of the region. As a graduate student, I spent one year in western New York, marveling at its epic snowstorms. Later I traveled through the western part of the Southern Tier, finding amazing stories there. I am always ready to get back on the Southern Tier Expressway in search of new adventures.

ROD SERLING'S LEGACY

Some of the stories I have collected have given me insight into the life of Rod Serling, who put the Southern Tier on the map of American folklore of the supernatural. One eloquent storyteller, retired Broome Community College Professor Robert Keller, told me about his boyhood friendship with Rod Serling, which began in the 1930s. At that time, Southern Tier children spent many hours playing outside in parks. Binghamton's Recreation Park had a frozen pool that drew a crowd of young skaters in the winter. While skating there, Keller met a new friend:

> *I was skating away. This kid came over to me and said, "Do you see that girl over there?"*
>
> *I said, "Yeah."*
>
> *He said, "Her name is Mary. If you skate up behind her and yell her name, she'll fall down!"*
>
> *I said, "Oh, neat!" Well, I skated up, I yelled to her and she fell down. I came back and said, "That was great! What's your name, kid?"*
>
> *"My name is Roddy Serling. What's your name?"*
>
> *"My name is Bobby Keller."*
>
> *And he said, "Where do you live?"*
>
> *I said, "I live on Grand Boulevard. Where do you live?"*
>
> *He said, "I live on Bennett Avenue. Do you want to come over to my place for lunch?" and I said, "Yeah, I'd like to." So that's how we met.*

This amusing story recalls Serling's love of adventure, which eventually made him the creator of a new kind of entertainment on television.

As Keller and Serling grew, they explored Binghamton's old cemeteries. They enjoyed having lunch beside a certain grave monument, playing roles from classical antiquity. Keller explains:

> *We both got our bicycles about the same time. He used his a lot for delivering groceries from his father's meat market. We'd go out together and take a sandwich; we used to like Spring Forest Cemetery. I was learning to play the recorder, and we would sit in front of one of the mausoleums and pretend that it was a Greek temple and we were Greek shepherds. He was a wonderful guy. It was such a tragedy that he died so young.*

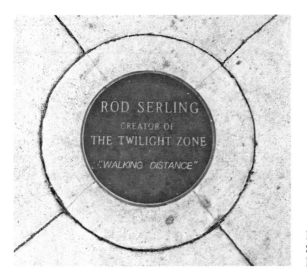

Plaque in memory of Rod Serling in Binghamton's Recreation Park.

Fast-forwarding from those quiet days in the 1930s to our more hectic era almost seventy years later, we can feel pleased that Serling now has his own monument in Recreation Park: a plaque at the center of the park's bandstand that honors his *Twilight Zone* episode "Walking Distance." In this episode, a man meets his boyhood self on a carousel and causes the accident that gives him lifelong lameness.[2] Because of Serling's connection to "Rec Park," some teenagers say that he haunts its carousel. Others tell stories about a spectral policeman and his dog, Sarge, who patrol the park's borders. These bits of ghostlore help us remember that Recreation Park has been a significant place for the Southern Tier's young people.

Monuments
(Endicott, Vestal, Elmira and Centerville)

Rod Serling is not the only Southern Tier citizen who has earned his own monument; there are many others. Martha Norkunas, author of *Monuments and Memory* (2002), reminds us that monuments "illuminate ideas about memory, history, power, class, ethnicity, and gender."[3] Writing about monuments in the industrial city of Lowell, Massachusetts, Norkunas notes that stone, metal and other materials preserve memory in tangible form, while stories function as another kind of monument. Like Lowell,

Binghamton and other Southern Tier cities retain traces of the busiest part of the Industrial Revolution in America, when immigrants came together in factories and railroads rushed supplies from one part of the country to another. From the second half of the nineteenth century to the first half of the twentieth, the aftermath of the Industrial Revolution flourished in upstate New York.

Among the most eloquent reminders of the Southern Tier's industrial past are abandoned, dilapidated factories, which once bustled with productive activity. Although these buildings were not intended as monuments to "big business," they serve that purpose. The shining white buildings of International Business Machines (IBM) in Endicott remain functional, but old warehouses near the railroad tracks crumble more every day. Southern Tier residents who care about their region's history have put up plaques to remind people of those individuals who preceded them: canal-builders, railroad men, soldiers and other hardworking folks who cared about their communities. Some of the plaques on busy streets barely earn glances from people driving by. Others, however, have more accessible locations.

One such location is Vestal's Rail Trail, a paved-over railway bed where trains chugged by until 1959. Summer brings out Rail Trail hikers: retirees

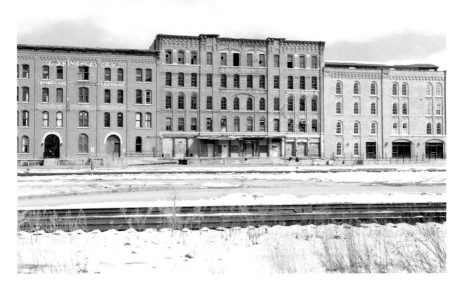

Abandoned factory buildings by the railroad tracks in Binghamton.

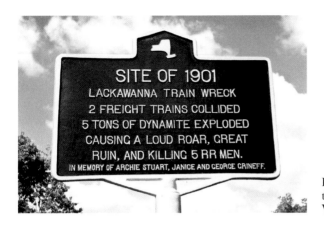

Plaque in memory of the 1901 train wreck on Vestal's Rail Trail.

walking dogs, parents strolling babies, teens meeting friends. In this informal gathering place, people discuss pets, weather and current events. Many of these folks don't know each other's names, but that is not a problem. What matters is getting exercise and sharing good times when the weather lets people leave their homes. My husband, our dog Molly and I enjoy Rail Trail conversations most mornings; we try to walk at least two miles every day.

Rail Trail hikers do not talk much about the trains that used to rush through the Southern Tier, but some remember the rhyme created by the Delaware, Lackawanna and Western Railroad to promote rail travel in 1900: "Says Phoebe Snow, about to go upon a trip to Buffalo: 'My gown stays white from morn till night upon the Road of Anthracite.'" Phoebe Snow was a fictional character who traveled in a white dress, enjoying the purity of clean-burning anthracite fuel. The train that went through Vestal bore her name. In spite of this upbeat advertising, not all early twentieth-century train journeys ended happily. A metal plaque near one end of the Rail Trail reminds us of the catastrophic train wreck that occurred shortly after the turn of the twentieth century. On June 9, 1901, two freight trains collided, exploding five tons of dynamite stored in a Delaware, Lackawanna and Western freight car. Five railroad workers lost their lives, and almost every house in Vestal lost window glass from the vibrations of the explosion. Whenever I walk past the railroad workers' memorial plaque, I hear echoes of that terrible sound, a sad and significant moment in the Southern Tier's railway history.

Another Rail Trail monument offers a tribute to Traci Gibson, who died of breast cancer in 2006. Although she received a diagnosis of stage 3B breast cancer at the age of thirty-one, Gibson, the mother of three young sons, refused to give up hope for her own and others' recovery.

While undergoing chemotherapy and radiation, she appreciated the help she received from fellow residents of the Southern Tier. Her foundation, Traci's Hope, now provides funds for both women and men who have breast cancer. Gas, rent and day-care funding from Traci's Hope has improved the daily lives of breast cancer patients in the Southern Tier. Gibson's smiling face, engraved on a flat black stone, reminds passersby of her indomitable spirit.

Other Southern Tier cities and towns also honor their dead with monuments. Elmira's Woodlawn National Cemetery has two: the Shohola Monument, in memory of a 1863 railway accident that killed both Confederate and Union soldiers, and the United Daughters of the Confederacy monument in memory of almost three thousand Confederate soldiers who died at the Civil War camp for Confederate prisoners that was known as Camp Rathbun. Inmates nicknamed this prison camp "Hellmira." Although some Americans might not know how many Confederate soldiers died there, Southern Tier residents are well aware of that sad fact. This monument and others erected after the Civil War remind us of the many losses that took place then.

Some monuments double as signs that identify places of interest to visitors. In Lost Nations State Forest, near the town of Centerville in Allegany County, a wooden sign identifies the forest's 1,344 acres as the place where a Native American community vanished without a trace. Anyone who wants to know more about the Lost Nation should go beyond the wooden monument to consult oral tradition. Eighteen-year-old Brian Van Houten told this story in 1964, as recorded in Catherine Harris Ainsworth's *Legends of New York State*:

> *In the frontier days a tribe of friendly Indians occupied this valley. Frontier traders used to trade with these Indians every year with the exception of the winter months, during which time the trails were usually impassable. Every spring the traders came back to the encampment to do business with the Indians. One year, after a hard, long winter, the traders came to the valley only to find no trace of the Indian encampment. They could find no proof that the encampment ever existed. There were no graves, arrowheads, remains from campfires, or any other evidence that Indians had ever been there. The traders sent out scouts to find out where the Indians had moved but they, also, could find no trace of the tribe. To this day the valley is known as "The Lost Nation," and still no one knows whatever happened to the Indian tribe that lived there.*[4]

This story, like Virginians' tale of the lost colony in Roanoke, describes a community that inexplicably vanished; it is one of the unsolved mysteries of New York's early days. The story's focus on how little we know gives it dramatic quality and makes us wonder whether it is possible to find more information. While monuments of wood, stone and metal retain the same size and shape, variants of stories are constantly changing. If more archaeological excavation takes place in the vicinity of the Lost Nation, we may be able to tell a clearer story about this Native community's disappearance someday.

SQUARE DEAL AND A BOOT-SHAPED POOL (JOHNSON CITY AND ENDICOTT)

We can compare the Southern Tier's topography to the landscape of the Hudson Valley, which Judith Richardson describes in her book *Possessions* (2003). Richardson notes that the "brooding mountains" and "spooky woods" of Hudson Valley legends have a close relationship to "a history troubled by restless change and contentiousness, which yielded haunting uncertainties."[5] In contrast to the Hudson Valley, the valleys formed by Southern Tier rivers do not have huge mansions, massive bridges or craggy cliffs. Their history may not be quite as contentious as the history of the Hudson River Valley, but some conflicts have caused trouble. The Southern Tier has its own distinctive identity. Its rivers, gentle hills, fields, forests and lakes make the area ideal for outdoor activities. Several cities have become good-sized population centers. Known as the "parlor city" and the "carousel capital of the world," Binghamton draws a good number of tourists during the summer season. Corning's Museum of Glass offers a dazzling array of historical and contemporary glass sculptures, and Elmira College's Twain Center has many visitors. Allegany State Park, New York State's largest park, offers 652 campsites, some within areas where early New Yorkers settled. Farther west, the Spiritualist community of Lily Dale welcomes visitors who wish to consult psychic mediums. While these parts of the Southern Tier all have their own history, together they form a region rich in culture, religion and natural beauty.

The Southern Tier's culture has grown through interaction of people from varying ethnic backgrounds. Early settlers came to this part of North

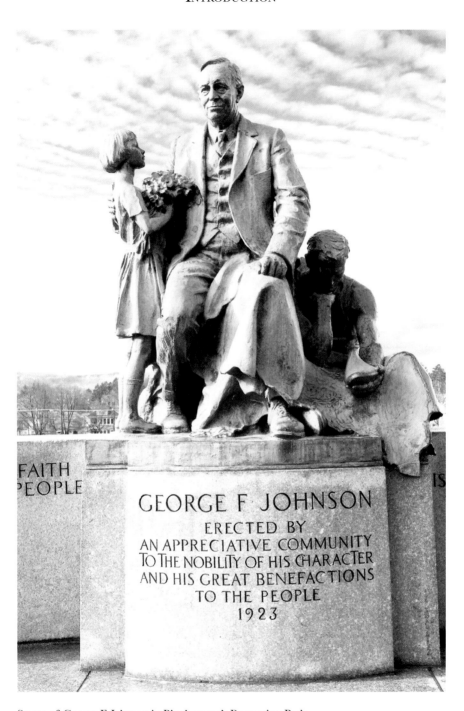

Statue of George F. Johnson in Binghamton's Recreation Park.

America from England, Scotland, Germany and France, among other places. From 1817 to 1825, construction of the Erie Canal drew workers whose original homeland had been Ireland. By the mid-nineteenth century, manufacturing was getting into high gear. The availability of good jobs for recent immigrants encouraged people from southern and eastern Europe and the Slavic countries to migrate to upstate New York. Through this combination of industry with immigration, an exciting experiment in fair treatment of factory workers began in the Southern Tier.

The Lester Brothers Boot and Shoe Company, founded in Binghamton in 1854, became the Endicott-Johnson Company in 1899 under the direction of Henry Bradford Endicott and George F. Johnson. Johnson, called "George F.," started a "Square Deal" system of benefits for his factory workers that included housing, medical care and recreational facilities. Factory workers who had recently come from Europe moved happily into their "E.J. houses" and became loyal members of the company's workforce. By the mid-1940s, the factory was producing more than fifty million pairs of shoes per year. In the 1950s, the factory continued to do well, but its prosperity gradually declined. Today a small part of the Endicott-Johnson shoe company remains, but it is no longer located in New York State.

Although E.J. no longer flourishes in the Southern Tier, its legacy remains strong. People who live in "E.J. houses" point proudly to their homes' special features, and senior citizens who once worked for the company reminisce about the "good old days" of free healthcare, lavish company picnics and swims in a boot-shaped pool. The profit-sharing program that George F. Johnson started for his employees in 1919 was a visionary venture, as was the design of Recreation Park, with its tennis courts, carousel, bathhouse and fountains. Chris Temple, author of "Real American Heroes," suggests that the Endicott-Johnson Company was "the greatest, and certainly the most noble, company in American history."[6] Those of us who live in the vicinity of Binghamton, Endicott and Johnson City today remember George F. Johnson's uncommon kindness to his workers, and schoolchildren learn to look up to the Johnson family's ideals. George F.'s provision of homes and other benefits to his company's workers reminds me of George Bailey's kindness to workers in the town of Bedford Falls in *It's a Wonderful Life*, one of my favorite films. Like Bedford Falls, Binghamton, Johnson City and Endicott have offered young families great opportunities for happiness and prosperity.

FESTIVALS AND OTHER SPECIAL EVENTS

Having grown through immigration, the Southern Tier has developed many festivals, arts and crafts shows and celebrations of cultural diversity. Among the many summer get-togethers are Owego's Strawberry Festival and Hickory Smoked Blues Festival, Wellsville's Balloon Rally and ATV Farm Fest and Binghamton's Spiedie Fest and Blues on the Bridge. There are also numerous ethnic celebrations organized by Greek, Ukrainian, Polish, German, Irish and other cultural groups. In the fall, Corning's Jazz and Harvest Festival attracts a large crowd. During the winter holidays of November and December, Roberson Center in Binghamton exhibits trees that represent different faiths and nationalities. After the long winter, Elmira's Maple Syrup Festival gives Southern Tier folks a chance to celebrate the return of the spring, when everyone can enjoy maple sugar candy and traditional crafts.

Besides these seasonal festivals, other special events encourage artistic self-expression. The Rod Serling Video Festival, organized by Binghamton schools, offers student video-makers a chance to excel in many categories of filmmaking. Art shows around the Southern Tier let young artists display their best pieces. Literary contests and open mike readings at coffeehouses encourage serious effort. Around the Southern Tier, young and older people take great pride in their creative work.

TROUBLE AND TRAGEDY

Unfortunately, festivals and celebrations have formed just one part of the Southern Tier's history. Its multicultural population has gone through some very difficult times, some of which have been related to ethnic diversity. From 1923 to 1927, the city of Binghamton served as the headquarters of the northeastern division of the hate-mongering Ku Klux Klan. As late as 1956, the *Binghamton Press* matter-of-factly published announcements about changes of location for Klan meetings. After the historic election of Barack Obama to the presidency in November 2008, an interracial couple found a cross burning on the lawn of their home in Susquehanna County, Pennsylvania, close to New York's Southern Tier.

Although nobody knew who had set the cross on fire, it seemed clear that hatred and fear had motivated that troubling act of vandalism.

On April 3, 2009, a mass murder took place at the American Civic Association in downtown Binghamton. A man who had previously studied English at the American Civic Association suddenly entered the building and began to shoot, killing thirteen people, wounding four and finally killing himself. This horrifying crime left Southern Tier residents grief-stricken and shaken. How could such a terrible thing have happened in our peaceful region that had welcomed so many immigrants? Mourning those who had died—some from China, others from Pakistan, Brazil, Haiti, Vietnam, Iraq, the Ukraine and the Philippines—we struggled to understand what had happened. Memorial services have honored the dead, and monuments are beginning to appear.

Telling the story of a painful loss can make the loss a little easier to handle. One of my former students, Nancy Barno Reynolds, has made a documentary film about the American Civic Association tragedy. This film, shown in the summer of 2010, has been very meaningful to Southern Tier residents. Presenting interviews with relatives of the victims and with emergency responders, it has helped viewers comprehend the tragedy and grieve together.

Out of the Ordinary

Most Southern Tier ghost stories concern deaths that happened a long time ago. Soldiers' ghosts, for example, remind us of losses of life during the Revolutionary War, the Civil War and other conflicts. Now that some time has passed since the terrorism of September 11, 2001, ghost stories on this subject have begun to circulate; one of those stories appears in chapter five. Narratives of this kind remind us that spirits of the dead can console the living.

Besides offering consolation, ghosts create excitement. Coming from the realm of the dead, they help us understand that little-known place. When I asked Father John Martinichio, the rector of Christ Church in Binghamton, why people like ghost stories, he answered:

I think it's a connection to the past, almost a continuation of a story. We're not operating in a void or a vacuum; we're operating in connection with people who have gone before us. In the church we call that the communion of saints. But also, I think it's something out of the ordinary. It's something new, something fascinating, something different *that we normally don't experience or understand.*

Ghosts certainly are out of the ordinary, interesting and different from what most of us encounter in our usual day-to-day routines. They connect us with family, local, regional and national history, and in doing so they bring us new perceptions. The next seven chapters explore mysteries that intrigue many Southern Tier residents. Some of these come from very old stories, others from more recent events. All of them reflect a lively interest in the past, which keeps bubbling up into the present.

CHAPTER 1
NATIVE AMERICANS

As you drive westward down the Southern Tier Expressway from Binghamton to Jamestown, you enter Seneca Nation territory. The Ohi:yo' River crosses the expressway more than once. Ohi:yo' means "good river" in the Haudenosaunee (Iroquois) language. Non-Native people call this swiftly flowing river the Allegheny. Not far from the river's twists and turns, the enormous Seneca Allegany Casino offers entertainment to Americans and Canadians. Here, on the western edge of the Southern Tier, you can easily imagine Native Americans hunting deer, bear and other animals. Throughout the Tier, however, supernatural narratives remind us of the importance of the people who first settled this region.

These people settled in the river valleys and on the hills created by glaciers' slow retreat. Hunting, gathering and fishing supported them from about 8000 BCE until the beginning of the Woodland Period around 1000 BCE, when agriculture developed. Archaeological digs in Endicott and other Southern Tier sites have shown that Woodland Period people cultivated corn, beans and squash. The Five Nations of the Haudenosaunee—the Mohawk, Seneca, Onondaga, Oneida and Cayuga—formed a prosperous and politically complex league by the sixteenth century. In 1722, the Tuscarora joined the League of Peace and Power as its sixth nation.

Eighteenth-century records describe settlements surrounded by palisades, where people lived in longhouses. Among these settlements were Onaquaga, near the current town of Windsor, and Otsiningo, the "southern door of the Iroquois longhouse," extending from present-day Chenango Forks to

Diorama of the Sullivan-Clinton expedition by James D. Baker, courtesy of the Owego
Historical Society.

Binghamton, according to Gerald Smith's *The Valley of Opportunity* (1988).[7]
On the western side of the Southern Tier, as well as farther north, the
Seneca maintained their league's western door, while the Mohawk guarded
the eastern door close to New England. Within these boundaries, intricate
oral traditions developed. Tehanetorens's *Legends of the Iroquois* (1998) re-
creates early Six Nations pictographs that tell such important stories as
"The Flying Head," "The Fierce Beast" and "The Gift of the Great Spirit."
The marvelous events and enduring values of these stories demonstrate the
strength of Haudenosaunee traditional storytelling, which has continued up
to the present day.

European colonization brought anguish to the Haudenosaunee. In *The
Ordeal of the Longhouse*, Daniel K. Richter explains, "Today, the ordeal of the
Longhouse is no nearer an end than it was in the 1730s."[8] At the beginning
of the Revolutionary War, some of the Haudenosaunee fought on the side
of the British. Among these fighters were the Seneca chief Cornplanter
and the Mohawk leader Joseph Brant. Because of the strength of the
Haudenosaunee resistance, George Washington sent Major General John
Sullivan and Brigadier General James Clinton into upstate New York in the

summer of 1779. On August 29, the Battle of Newtown took place on what would become Sullivan Hill above the Chemung River near Elmira. The battlefield, now a historic landmark, covers parts of the towns of Elmira, Chemung and Ashland. By the end of the battle, Sullivan and Clinton had defeated the Haudenosaunee and Tories. Later, the two generals destroyed many towns, leaving people who fled from the battle to starve during the winter. Having lost their homes, livelihood and lands, the Haudenosaunee suffered greatly.

More than two hundred years have passed since those searing conflicts, but their legacy remains a part of the Southern Tier. Ghost stories articulate some of the pain of that legacy, mentioning changes in the landscape and tension between Native and non-Native people. Although place names at colleges, parks and other sites honor the Haudenosaunee, the locus of power has shifted from Native Americans to politicians of the United States. There is an enormous difference in viewpoint between stories told by Native people and stories told *about* native people by others. Let's begin with some of the stories told by Native people themselves, which offer the best understanding of their traditions.

Elma Jones's essay "From the Tuscarora Reservation," published in *New York Folklore Quarterly* in 1949, gives us a glimpse of Haudenosaunee ghost stories toward the end of the first half of the twentieth century. A member of the class of 1950 at Cornell University, Jones writes from the dual perspective of Native American heritage and mainstream higher education. She sadly describes the decline of Native languages:

> *The younger generations, including myself, are unable to speak the language or even understand it. They are unable to work at the Indian crafts, and some feel that it is degrading even to admit that they are of Indian heritage. Had it not been for the stern teachings of my Indian father, I too would be unable to appreciate the culture of the Indian people.*[9]

Jones explains Tuscarora relatives' reluctance to share stories because they "are afraid that the white men will not understand them and will ridicule their beliefs, customs, and traditions."[10] Fortunately, she succeeded in gathering some very fine legends about ghosts, witchcraft and a cannibalistic giant. One of the most suspenseful stories came from the great-grandfather of its teller, who describes a man's horror at being pursued by a skeleton late at night. Here is the part of the story in which the man makes that discovery:

As Great-Grandfather turned around, all that he could see was a small red light coming along the trail. He heard the moan, saw the light, and he knew that the man following was not human and living but a skeleton. His heart beat faster, his head was pounding, and cold perspiration was covering his body. He was so scared he couldn't even pick up his feet to run, and then as he looked toward his destination he saw coming the lighted torches of the Indian runners. Again he heard the long, low moan of the skeleton, as if at his heels, and he fell to the ground too weak to get up, so he began to crawl. This time the approaching men heard the skeleton, and so they ran faster, waving their burning torches and yelling.[11]

This suspenseful account of a skeleton pursuing a human being helps us understand Haudenosaunee legends of the mid-twentieth century. Another collection of Tuscarora legends by Anthony F.C. Wallace (1949) includes an exciting story about a man's escape from a skeleton by hiding inside a hollow log, as well as another story about a man who dies of fright when a ghost goes after him. Wallace mentions that Tuscarora children as young as three or four years old knew these stories well.[12] Since the stories were told as true experiences, the children took them very seriously.

Master storyteller DuWayne (Duce) Bowen, a resident of the Allegany Indian Reservation at Jimerstown-Salamanca, narrated the Seneca ghost stories of his childhood in two volumes: *One More Story: Contemporary Seneca Tales of the Supernatural* (1991) and *A Few More Stories: Contemporary Seneca Indian Tales of the Supernatural* (2000). A descendant of the Seneca chief Cornplanter, Bowen recalls enchanted childhood summers when his grandmother would gather all the children around and "spin a tale to stand [their] hair on end."[13] Sitting on their grandmother's rough wooden porch, the children took great delight in her spine-tingling stories. Bowen passed away in 2006, but his ghost story books keep his family's traditions alive.

One very interesting legend from Bowen's first book, "The Skeleton in the Sky," describes a group of young men who spot a sky-walking skeleton dressed in a headdress and costume. When they ask their older relatives what this apparition means, the relatives agree that a war will come soon and that young soldiers will die then. A parenthetical note explains, "In December of that year, the Japanese bombed Pearl Harbor. A certain number of these boys went to war. Some survived; one was maimed; some were killed. One of these boys was returned home twenty

years later; a skeleton."[14] This chilling story identifies ghostly messengers as bearers of omens that have a good chance of coming true.

Another skeleton story in Bowen's first book describes the deaths of a mother and daughter after a new power line upsets members of a Native community. At the story's beginning the narrator explains, "The power line scared some people because they were afraid that the electricity could kill them."[15] When men start hunting near the power line, new pathways form, and men start using one of the paths to go to a village to buy alcohol. One young man drinks too much, gets involved with another woman and hits his wife on the mouth when she comes looking for him. Overcome with sadness, his wife tells her daughter that "she [has] to go to the power line."[16] Before walking in that direction, she gives her daughter her ring, telling the little girl that she loves her and will come back. Later the daughter wanders away, telling another child that someone near the power line is calling her. The narrator describes what happens next:

> We searched for a few hours and then some men came upon a terrible sight. They told the women and kids to stay away from there. When I got there I saw grown men with tears in their eyes. One or two were crying softly. I got tears in my eyes too when I saw the two bodies. The wife's skeleton had its arms wrapped around the body of the little girl. The little girl looked content in death. But now the ring which the little girl was keeping for her mother was back on the skeleton's finger.[17]

This story shows how stressful the construction of a power line can be for a small community. The power line brings death, but it cannot erase the love between a mother and her daughter.

Trouble caused by a power line is only one of the disruptions of Native people's life that Bowen has chronicled. He mourns the loss of Seneca land and homes that followed the construction of the Kinzua Dam on the Allegany River: "Within a year and a half we lost practically all of our old people. They died of broken hearts. The Kinzua Dam ended a way of life. I really miss the old road."[18] This sad loss, which resulted from officials breaking the Pickering Treaty, was very hard for the Seneca people. In the memories of those who lived on the now-flooded land, the old ways are still there.

One of my favorite Haudenosaunee stories is Bowen's rendition of "High Hat" in Mason Winfield and Terry Fisher's film *Phantom Tour: The*

Thirteen Most Haunted Places in Western New York (2003). Before he begins the story, Bowen points to Ga'hai Hill in Allegany State Park, explaining that a bloody battle took place there a thousand years ago. In this location marked by death, a cannibalistic giant walks:

> *There's a creature that is man-like. He stands as a man, walks like a man. Looks very much like a man. Whenever he has been seen in the woods, he is wearing a high hat, a stovepipe hat. People who have seen him close, up close and personal, say that he has a very gruff voice and is supplied with an ample amount of sharp teeth. He is a meat eater. He travels in swamps, in streams, wherever there's food, on the riverbank itself. So that goes right through what was the old Witches' Walk, and High Hat could be there. People have tried to camp there, especially on Ga'hai Hill, and they just can't do it, because of the real heavy evil feeling. Something is not right there.*[19]

Hearing this scary story, we can understand why young people (and perhaps some older ones) hesitate to camp out on Ga'hai Hill on summer nights. Some commenters on Bowen's story on the Internet have said that they wouldn't camp there for a million dollars. As in other legend cycles, the names of the cannibalistic giant vary. Sometimes he is High Hat; other times he is High Top. No matter what people call him, no one wants to see him. This is one of the most frightening supernatural figures known in the Southern Tier.

Let us turn now to ghost stories told by non-Native people, which differ greatly from the stories told by Native people themselves. We will begin with some of the older material, which reflects the unfamiliarity of Native people to settlers on new territory, and then turn to some more recent stories.

TREASURE LEGENDS
(BANKS OF THE SUSQUEHANNA RIVER)

Back in the days of exploration and settlement, non-Native people in New York's Southern Tier and Pennsylvania's Northern Tier told stories about Native Americans guarding fabulous treasures. When early non-Native explorers traveled up the Susquehanna River, treasure legends exerted

Susquehanna River banks near Roberson Center in Binghamton, where members of the Sullivan-Clinton expedition disembarked from their boats in 1779.

a powerful fascination. As recently as the 1970s, elderly people in small Southern Tier towns told their grandchildren to watch out for treasure on the riverbanks. Today, participants in treasure-hunting websites enthusiastically trade stories about old silver mines and other kinds of buried treasure.

I have found no evidence of riverbank silver deposits in the Southern Tier, but that lack of evidence has not kept people from telling stories. We can account for the stories' persistence not only by people's desire to get rich quickly but also by the symbolic meaning of Native treasure. Whether or not any old silver mines actually exist, we know that the original residents of New York State lived on lands of extraordinary richness and promise. Deep forests, fallow fields, wild game and other resources made this part of the world a treasure of incalculable value. It is not surprising that early settlers expressed their awareness of Native people's wealth in treasure legends.

Some of my first students at Binghamton University knew legends about treasure buried in the Southern Tier. One student, Linda, collected this story from a relative in 1979:

Somewhere along the Susquehanna River is a hidden silver mine. The Indians knew where it was and showed it to two white men, who they let work on the mine. These two men worked the mine for a while and made some money, but they never showed the whereabouts of the mine to anyone else.

Then the war broke out. The Revolutionary War. And these two went off to fight. Well, to protect their mine, they rolled a large stone [gestures to indicate size of stone] *in front of the mine entrance. Then they marked the trees so that they could find their way back to the mine in case they were gone a long time. The stone was to keep anyone from looking into the mine, to keep them from seeing the mine. It was such a big stone that it took two men to move it and you wouldn't want to move it, unless of course you knew about the mine, which nobody did. Except for the two that put the stone there in the first place.*

Anyway, after the war was over one of the men returned to the mine. The other must have been killed. But this man couldn't find the mine. Seems the Indians that had showed them where the mine was in the beginning had burned all the trees and changed all the other landmarks so that the man couldn't find his way back to the mine.

To this day no one has ever found the old mine. Some say that every seven years a light, like the light of a candle, is supposed to rise above the old mine at just midnight and then it disappears. But of those that say they've seen it at night, none of them has found it in the day. I've never seen it.

Contrasting cultures shape this story: the two Native characters share their hidden silver mine with the white men, allowing the men to work there. Without asking their Native guides for permission, the two white men take over the mine, make money and block the mine's entrance so that no one else can find the place. A fitting consequence comes from their greedy behavior; because of their eagerness to protect what they viewed as their own property, no other white people can find the mine. True to the form of many traditional Anglo-American ghost stories, a "spirit light" hovers over the mine at midnight and then vanishes.

A second treasure story, collected by Linda from the same relative in 1979, describes Spanish pirates, whom we would not usually expect to find in a ship on an inland waterway. The legend follows:

The pirates buried [their treasure] *so that if their ship was taken their treasure would be safe. They must have been chased by someone. They came up the river, buried the silver and then took off, back the way they came. Nobody came back for the treasure, and it's still there somewhere.*

Old Joe heard from these Indians about a buried treasure. The Indians had seen the pirates bury the stuff and told Old Joe about it. It was supposed to be buried on a hill someplace over the river. Old Joe went looking for the treasure but still didn't find it. Next time he saw the Indians that told him about it, he asked them where it was. They told him that there was a curse on the spot and they couldn't tell him where it was, but if he sacrificed a white dog the gods would show him where it was. Joe couldn't find a white dog, I guess, cause he killed a sheep or some other animal that was white and looked like a dog. The gods were smarter than Joe thought they were and didn't fall for his trick like he had hoped. They never let Old Joe find the buried treasure.

The Native Americans in this story do not offer Old Joe any undeserved generosity. Instead, they tell him that the only way to find the treasure's accursed burial site is to sacrifice a white dog. Lewis Henry Morgan's *League of the Iroquois* (1972) explains that participants in the Iroquois New Year festival used to burn a white dog to commune with their Great Spirit.[20] Not being a member of this religious group, Old Joe substitutes another white animal. Old Joe never finds the treasure, and the curse on its burial site continues.

"Ghosting" (Elmira, Corning and Owego)

As I found while researching my earlier book *Haunted Halls* (2007), non-Native people's legends about Native Americans tend to emphasize strangeness and suffering.[21] Perceiving Native people as different from themselves and remembering past struggles with the settlers who became dominant, non-Native narrators focus on tragic early death. I agree with Renée Bergland's assertion in *The National Uncanny* (2000) that mainstream American culture's dominance has made Native Americans seem to non-Natives like ghosts, far away from society's center.[22] Since the displacement

of our nation's first residents to reservations, many legends have portrayed Native people as ghosts. Emelyn Gardner's study of upstate New York folklore, *Folklore from the Schoharie Hills* (1937), shows how this process has taken place. In one small community, she finds several people who recall an "Indian half-breed" who goes from house to house, scaring horses and bothering homeowners. One storyteller explains that this person "appeared in front of [her] like a ghost" and did not seem to understand what she said. Another narrator describes the man standing "stock-still" and then vanishing.[23]

In towns and cities of the Southern Tier, legends about Native ghosts circulate. Many of these legends do not come from specific tragedies. Some follow the popular nineteenth-century pattern of a tragic love story, in which an "Indian princess" dies after falling in love with a white man. Of course, Native people themselves did not use the term "princess," which came from European settlers' interest in royalty. Some areas in New York State have a connection to legends about sad, suicidal princesses. Here is one about the Chemung River valley between Elmira and Corning, told by eighteen-year-old Stanley Brodsky in Buffalo in 1963 and collected in Ainsworth's *Legends of New York State*:

> *There once was an Indian girl and a Frenchman who were having a love affair. The Frenchman's wife found out about the affair and threatened to have the Indian girl killed if the Frenchman didn't come back home. The Frenchman then left without explaining to the Indian girl the reasons why. The Indian girl thought he didn't love her anymore, so she committed suicide by jumping off a cliff. She landed on a ledge about one-third of the way down and died there. The Frenchman heard about this and came back and erected a cross on the very place where she landed.*
>
> *To this very day, there is a cross on one of the cliffs overlooking the Chemung River between Elmira and Corning, and no one knows how it got there.*[24]

This young woman's suicide has a certain tragic irony. The Frenchman has stayed away to spare her from death at the hands of his wife, but his unexplained absence makes her commit suicide. Some people living near the Chemung River have commented that a mysterious painter freshens the cross's white paint every year. Could the painter be a descendant of the young Frenchman? Whether the paint-freshening reflects romantic devotion or religious fervor (or both), no one knows.

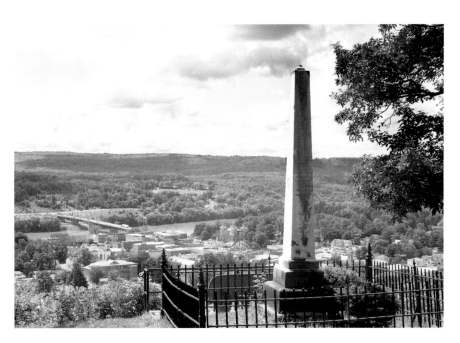

Obelisk that marks the grave of Sa Sa Na Loft in Evergreen Cemetery in Owego; she died in a train wreck in Deposit in 1852.

In most "Indian princess" stories, Native women fall desperately in love with non-Native men. Typically, these legends belong to the fictive history of towns in New York State and other parts of the United States, but some stories about young Native women have a foundation in history. One of those describes Sa Sa Na Loft, a twenty-year-old Mohawk woman who died in a train wreck in Deposit on February 18, 1852. Sa Sa Na was a Christian missionary who had devoted her life to sharing holy scripture with other Native people. Grieved and touched by Sa Sa Na's sudden death, the people of Owego insisted upon burying her in Evergreen Cemetery at the top of a hill in Owego. Her monument, a seventeen-foot obelisk, is one of the cemetery's most impressive monuments. There was some disagreement at the time of Loft's burial, because her brother wanted to bring her body home; however, the people of Owego succeeded in bringing her body to Evergreen Cemetery.

From the late nineteenth century to the present, Owego legend-tellers have explained that Mohawk visitors came to Loft's grave for many years.

Trees by the Susquehanna River in Owego; these old trees have borne silent witness to changes in the Southern Tier's population.

Eventually the Mohawk visitors stopped coming, but others tending their families' graves heard singing in the trees near Loft's obelisk. Words softly sung in the Mohawk language convinced these people that Loft's spirit and the spirits of her relatives and friends had remained in the cemetery. It is supposed to be easy to hear their singing late at night. When teenagers take legend trips to Evergreen Cemetery, they listen closely, eager to hear voices raised in song.

This story of a gentle, understated presence is typical of current legends about Native ghosts told by people of non-Native descent. I have heard stories about ghosts of Native people appearing and then disappearing as soon as someone sees them. In some stories ghosts run away; in others they simply dematerialize. Their brief presence reminds people that the Haudenosaunee League of Peace and Power once influenced daily life in the Southern Tier. We can view the spirits' presence as unfinished business—an attempt to complete a way of life that colonists interrupted and irrevocably changed. This earlier way of life is an important part of the Southern Tier's identity that returns to us in ghost stories.

CHAPTER 2
CHURCH FOUNDERS AND MEDIUMS

Two remarkable religions began in western New York in the nineteenth century. In 1823 in Palmyra, near Rochester, Joseph Smith had a vision that inspired the founding of the Church of Jesus Christ of Latter-Day Saints, also known as the Mormon Church. Twenty-five years later in the nearby hamlet of Hydesville, young Margaret and Kate Fox heard the first spirit rappings that would lead to the founding of Spiritualism. Both of these beginnings took place just above the Southern Tier, during the period of religious intensity that made people call western New York the "burned-over district."[25] At that time, interest in prophets, new forms of Christianity and religious revivals created a burst of activity in western New York.

Although this burst of activity belongs to the past, the Southern Tier still has many churches and an active Spiritualist community, Lily Dale. Over the years, Binghamton's churches have reflected increasing ethnic diversity. The shining golden domes of Ukrainian and Russian Orthodox churches add beauty to the city's skyline. One of the city's oldest synagogues, Temple Concord, owns the Kilmer Mansion on Riverside Drive. In Johnson City, Muslims worship at the Al-Nur Mosque. Respect for diverse religious beliefs has enriched the Southern Tier and facilitated the circulation of ghost stories. These stories range from humorous descriptions of lost objects to emotional accounts of encounters with deceased relatives. One chapter is not long enough to cover all of these stories, so let us look at a few that represent significant parts of our "burned-over" past.

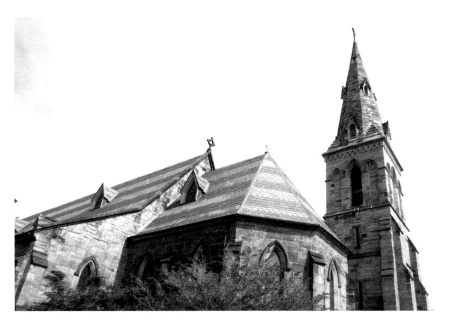

Christ Church, founded with the help of Joshua Whitney in 1810.

THE HEAVY GHOST OF JOSHUA WHITNEY (BINGHAMTON)

Joshua Whitney (1773–1845) came up with a clever way to bring settlers to the land purchased by the Philadelphia banker William Bingham (1752–1804) in 1786. Bingham envisioned a new town at the confluence of the Susquehanna and Chenango Rivers, but the residents of Chenango Village near the current village of Nimmonsburg did not want to move. Whitney traveled to the Chenango Village tavern, where he announced that he was marking two elm trees for a new bridge across the Chenango River that would bring a huge amount of commerce to the area. Whitney was such a passionate speaker that he persuaded most of the village residents to pack up their belongings and build houses near the new bridge, which went up in 1808. Through that piece of persuasion, he earned the title "the true founder of Binghamton," according to Smith's *The Valley of Opportunity* (1988).[26]

Once he settled down in the new village, initially known as Chenango Point, Whitney supported new ventures. One of these was a new Episcopal church, which Whitney and others co-founded in 1810. Whitney stood

out among the founders of Christ Church because his size was unusual for that time and place. Soon Whitney found that he could not worship comfortably because he was too large for the church's pews. Father John Martinichio, Christ Church's rector and a wonderful teller of stories, explained the dilemma that led to an unusual haunting:

> *Joshua Whitney was a man of about four hundred pounds. He went to the vestry, which is the group in charge of the parish; they're elected by the parishioners. Because of his size, he wanted them to remove a pew, and they said "No." From what I understand, he left here and ended up at Saint Pat's, on Leroy Street.*
>
> *Things happen here that are unexplainable, and of course we always blame* him. *When they did the carpet in my office, I had a pen that had been missing several months, so I went out and bought a new one. All my stuff was moved into the choir room. A lady had died; I went to the nursing home. I came back, was going to go to the house to meet the family and just moved my furniture back in and piled my papers on the desk. I came back from meeting with the family.* Both pens *were on top of the pile of papers, and the other one had been missing for months.*
>
> *We were missing a chalice for several years. One Sunday morning when the Altar Guild came in to set up for the morning service and opened up the cupboard, there it was.*
>
> *You just get the feeling sometimes that you're not alone. You hear doors open and close and things like that. So for the unexplainable things we say, "He did it. Joshua did it. It's his fault."*

Father John describes Whitney as a playful ghost who enjoys surprising people. Wondering whether being denied the chance to have a larger pew motivated the ghost's antics, I asked, "Do you think the ghost is a little resentful?" He answered, "Oh, sure, I think that's why he's still here. That denial or that anger must hold him here." Whitney seems to be both a playful and an angry ghost: a player of tricks who enjoys surprising the church's rector, staff and congregation.

Whitney's ghost gets our attention partly because it deviates from our usual expectations for ghosts' sizes. We tend to imagine ghosts as pale, ethereal spirits, not super-sized beings who demand extra space. In his passion for religious worship, village organization and good food, Whitney "lived large," and his ghostly behavior also occurs on a grand scale. His tricks remind people that he still belongs to the church. There is some

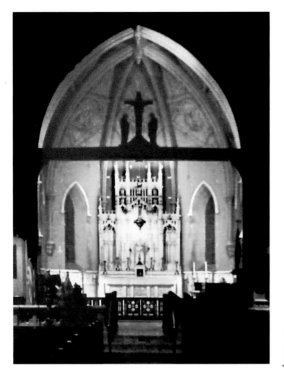

Church directory cover photo of Christ Church's altar, on which parishioners have seen the face of Joshua Whitney.

comic irony in his tricks: while alive, he needed a bigger pew, but as a heavy ghost, he can fit in anywhere.

Besides stories about Whitney's shenanigans, other evidence gives us a sense that he is still present in Christ Church. On the cover of a recent church directory can be seen the silhouette of a man's face. Can this be the face of Joshua Whitney, making his presence known to the current congregation? Although the silhouette has rough edges, it looks like Whitney's profile. This similarity has stimulated some lively conversation among members of the church.

As a founder of Binghamton and of Christ Church, Joshua Whitney had a strong impact on Southern Tier history. His ghost makes us think about religious devotion, unfinished business and playfulness. Don't we all need a little play in our lives? A lively, playful ghost adds excitement to daily routines while reminding us of past conflicts.

THE ANGRY GHOST OF THE BAPTIST CHURCH (BINGHAMTON AREA)

In contrast to the playful ghost of Christ Church, another spirit expresses anger toward family members. Paul Leader, a seventy-five-year-old resident of Apalachin, told this story to my student Stacee in 2009:

When my parents bought their house back in the 1930s, the woman who was selling it for her friends told us that the woman who originally built the house was the daughter of the Crowley family. Back then, the Crowleys had just started their dairy production company, and it had just started to become the successful business that it is today, making them one of the most prominent families in the Binghamton area. Another family, the Morgan and Ives family, were also a prominent family in the Binghamton area. They owned a mattress company; in fact, it just recently shut down in the last few years. The Crowleys had several children, and the parents were devout Roman Catholics who expected their children to be the same. The Morgan and Ives family were devout Baptists who, like the Crowleys, expected their children to be the same.

The Crowley daughter and the oldest Morgan and Ives son fell in love and decided to get married. The Morgan and Ives family did not have a problem with it, because the Crowley daughter had promised to convert to their religion; the Crowleys were infuriated, because they believed that she should remain Catholic, and due to her decision her parents disowned her. Her grandfather, however, had not always been a Catholic, and he tried to see things from his granddaughter's point of view: she was in love, plain and simple, and was going to do all she could to keep her relationship together. He and his granddaughter remained close, and when he died she received a large sum of money via an inheritance. Her parents were again angered by this decision, because they no longer viewed her as part of the family, and they tried to make her give it back. However, she had other plans for the money.

The Crowley daughter decided to take her inheritance and build a Baptist church near the mattress factory, which was also where her new marital home was, to thumb her nose at the idea that she did not deserve her grandfather's money and also at the fact that they were such devout Catholics. She furthered her f--- you by building a rectory for the preacher and his family and selling it to the church for one dollar. After

she had done this, her family was so angry that they began trying to take the property and destroying all she had done. Sadly, she died young, while giving birth to her second or third child—I can't remember which exactly—before she could make her family leave her and her marriage and her property alone. Her husband was very sad afterward, and many say he died as a result of his broken heart. And ever since, she has haunted the church and the home she built for its ministry to protect it from her family forever.

This long, detailed story of contrasting religious backgrounds and family feuds reminds me of Shakespeare's *Romeo and Juliet*.[27] Like the Montagues and the Capulets, the Crowleys and the Morgan and Ives families do not seem willing to give up any aspects of their daily lives for the sake of two young lovers. Only one relative, the Crowley daughter's grandfather, overcomes prejudice through love and leaves the young woman a generous inheritance. With this family money, she builds a Baptist church and a rectory to spite her Catholic family. After her early death, she dedicates herself to protecting the church and rectory from her Catholic family members. This is one of the few Southern Tier ghost stories that highlights long-lasting resentment. I have found no evidence that the story of the angry Crowley daughter is factual, but it is certainly true that the Crowley and Morgan and Ives families have all made important contributions to the Southern Tier's economic growth.

TALKING TO THE DEAD (LILY DALE)

One of my favorite destinations is Lily Dale, the heart of New York's Spiritualist religion. Amelia Colby founded this religious community in 1879, calling it the Cassadaga Lake Free Association. In 1903, its name was changed to City of Light, partly because it was one of the first places in the United States to get electricity. Finally, in 1906, the community's name became Lily Dale Assembly. Attracting many visitors throughout the summer season, Lily Dale hums with spiritual activity. Even though there is a busy schedule of services and workshops, a peaceful atmosphere prevails. Visiting Lily Dale feels like stepping back into the nineteenth century. Late nineteenth-century homes with wide, welcoming porches

convey a sense of friendliness and serenity. Besides enjoying walks in the quiet streets and eating tasty salads and sandwiches in the cafeteria, visitors can try to communicate with lost loved ones with the help of registered mediums.

Lily Dale was founded after the experiences of Kate and Margaret Fox in the hamlet of Hydesville inspired the beginning of Spiritualism. In 1848, twelve-year-old Kate and fifteen-year-old Margaret heard rappings that seemed to come from spirits. The two girls explained the rappings with a story: years ago, they said, a peddler had been killed in their cottage, and his spirit was communicating with them. At first the girls' parents could find no information about a violent death in their home, but in 1904, when the east wall of the cottage caved in, workers found the bones of a man and a small metal peddler's trunk, as recorded in Mary Cadwallader's *Hydesville in History* (2010).[28] This trunk now stands on a shelf of the Lily Dale Museum, protected by a glass case. From 1916 to 1955, the Fox family's cottage, relocated from Hydesville, stood in the center of Lily Dale. Then the cottage burned down; the only objects that could be saved were the Fox family's Bible and the peddler's trunk. A plaque now marks the spot where the Fox cottage stood—a holy place for members of the Spiritualist church.

Some early advocates of Spiritualism supported giving women the right to vote and abolishing slavery. Among the famous women who came to Lily Dale was Susan B. Anthony, who addressed an audience of three thousand people in an amphitheater adorned with flags in 1891. Anthony enjoyed readings with mediums, but not all of their responses pleased her. According to Lily Dale tradition, and as noted in Cara Seekings's *The Ladies of Lily Dale* (2010), a medium once told Anthony that a deceased aunt wanted to give her a message. Anthony tartly replied, "I didn't like her when she was alive, and I don't want to hear from her now. Why don't you bring someone interesting like Elizabeth Cady Stanton?"[29]

Messages from interesting people arrive every day at Lily Dale. At Inspiration Stump, the stump of a decayed tree near a pet cemetery in Leolyn Woods, people gather twice daily to hear messages presented by mediums. According to local legends, early residents of Lily Dale perceived so many spirits around this tree that it became a gathering place for everyone who wanted to communicate with spirits of the dead. As the tree's reputation grew, people took pieces of its bark home with them, and consequently the tree died. After the tree went down, its stump

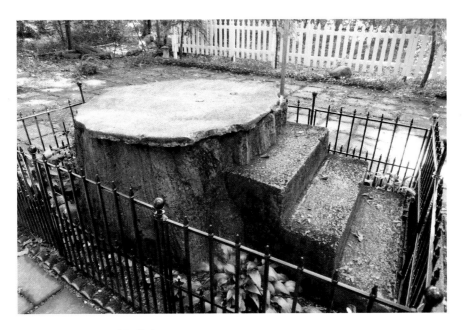

Inspiration Stump in Lily Dale.

served as a pedestal for mediums. According to journalist Christine Wicker's *Lily Dale* (2003), mediums' use of the stump as a standing place stopped "when one of them had a heart attack in midproclamation."[30] When Wicker asked medium Betty Schultz about her experiences near the stump, Schultz described seeing the spirits of two young men who had drowned. "'All right, boys,' [Schultz] told the spirits, 'We'll find you." With her help, police recovered the two young men's bodies.[31]

During a visit to Lily Dale in the summer of 2010, I attended several message services. Experienced mediums took turns contacting spirits, while student mediums observed and tried to do some contacting of their own. Before giving someone a message, a medium would ask, "May I come to you?" or "May I touch with you?" Each message included a brief story about the spirit as well as a few words of comfort and advice. One story told by a student medium about a spirit named Babe mentioned that Babe owned a lot of jewelry, "partied way too much" and developed "distress around the midsection." Her message for the middle-aged man who recognized Babe's name was, "You need to take better care of yourself, or you'll end up just like me." This kind of advice often concluded the spirits' visits: people should look after their

health, feel more self-confident and do what they most enjoyed doing. Encouragement to gain more self-confidence and fulfillment went to women more often than to men, an inclination that fits a community founded by feminists.

Most of the messages came from people who were not generally well known, with one exception: the famous Southern Tier author Mark Twain. A male medium told a young woman, "Things are getting you off track." Then he said, "I'm getting Mark Twain here. He would stand up and say things to people. He would say things outside the box. You can be like him." In this encouraging way, he asked the young woman to follow the example of an author who had dared to take chances. It was certainly true that Twain, like contemporary comedians, had pushed the envelope of acceptability to get his points across to readers and listeners.

All of the Lily Dale mediums have their own ways of receiving spirits' messages. Some focus on visual details, while others receive a broader range of sensory input. One female medium at the evening message service I attended asked a woman about a spirit that was contacting her: "Did he smoke? My mouth tastes like an ashtray." After receiving an affirmative answer, she told another woman, "I'm smelling roses. Does that remind you of someone?" Later she told a third woman, "I'm hearing music. You should go to Chautauqua. In a past life, you were a musician." The medium's brief mention of a past life belonged to the culture at Lily Dale, where past-life regression occurs in workshops.

While visiting Lily Dale, my husband and I stayed at Angel House, built in 1897, where hosts Shelley and Frank Takei offer guests a warm welcome. Each room of this three-story Victorian house has its own name and mode of decoration. Our room was the Goddess Room; the other seven guestrooms were the Fairy Room, the Cherub Room, the Crystal Room, the Red Angel Room, the Blue Angel Room, the Moon and Stars Room and the Harry Potter Room. It was a delight to stay in this beautifully decorated house, which combined spirituality with playfulness. The Takeis served a light breakfast and encouraged their guests to spend time relaxing in the comfortable chairs on the front porch. In the midst of the busy summer season, I did not have much time to talk with the Takeis, but Frank kindly told me about the spirit of a woman who had once made herself known on the third floor:

A friend of ours, a medium, told us she found the spirit of a woman on the third floor of our house. She said the woman would appreciate a rocking chair. We had a rocking chair at home, so we brought it up to the third floor. Of course we never saw anything there, though. We don't have much communication with spirits. There used to be a single woman who lived on the third floor. We think maybe it's her.

This narrative suggests that the house's earlier resident may still be there, looking for the right kind of chair. Frank Takei seems comfortable with the idea of spirit guests, but he and his wife do not actively seek that kind of communication. Nonetheless, they enjoy sharing stories about spirits' visits to their lovely guestrooms. When I asked Frank whether anyone had mentioned spiritual activity in the Goddess Room, he told me, "I've slept in your room too. I kept hearing a party going on and said, 'Somebody's having a party in here.' Other people have made that observation too." Christine Wicker's book about her summer there offers more information about this wonderful guesthouse.[32] There are also other interesting guesthouses and hotels where you can stay at Lily Dale, if you wish to visit the community.

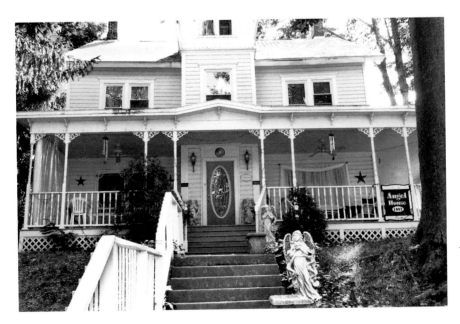

Angel House, built in 1897 in Lily Dale.

A Young Medium (Horseheads)

Most of the mediums at Lily Dale are middle-aged or elderly. The role of a medium is not one that young people typically choose these days, so I read with great interest an article about a fifteen-year-old medium in Binghamton's *Press and Sun-Bulletin* in April 2010. Written by journalist Peg Gallagher, this article introduced Nicole Rose of Horseheads, who had demonstrated spiritual gifts as a young child. The article included several photos of Nicole: one with her mother, Josette Berardi, another with a framed photograph of Nicole's great-grandmother and a third with her cello. A sidebar mentioned Nicole's willingness to give readings for interested individuals or groups. "I want to use my gifts to help people…to give them guidance," Nicole explained. "I feel like I'm on a journey."[33]

Impressed by Nicole's desire to help others, I asked for a reading; she and her mother agreed to come over. We decided that I would ask a few questions first, and then Nicole would do a reading for me. The two of them came over on a warm summer evening after doing a couple of readings for people in Binghamton. We talked about Nicole's summer vacation and my work at Binghamton University. When I asked Nicole about her plans for the future, she told me she wanted to become a forensic anthropologist. It was clear that she was a very intelligent, kindhearted young woman with strong motivation to assist others through readings.

"How did you learn that you were a medium?" I asked. She answered, "I was ten. I saw the apparition of my stepgrandfather, and then I watched a TV show about mediums." Watching actors portray mediums on TV helped her recognize her own talent. According to her mother, visits from her long-dead great-grandmother also helped Nicole learn about being a medium. Berardi explained:

Nicole was named after this grandmother, and of course we didn't know my grandmother was [a medium]. *Since Nicole has come out with her abilities, she said my grandmother used to visit her, even when she was a small child. They were very close. My grandmother then conveyed to her that she did have these abilities, but she was afraid to tell people because she thought they would say things about her. So that's how we confirmed it, through spirit communication.*

Berardi, an eloquent storyteller, described Nicole's early childhood:

She knew she was different. She would do all kinds of outlandish things until she was about five, and then she seemed to turn [her gift] off. I think she started to realize, "I'm different." Then she started to have some bad experiences, so we put her into training. She didn't need training to advance her gift. It was more like how to turn it off, because she was just open to everything. Everything would come through. It got to be pretty scary.

Nicole's training at Lily Dale's Trilogy Institute began when she was fourteen. She went through several stages of training and was one of just a few students who made it to the final stage. Her teacher, Patricia Price, who has a master's degree from the State University of New York and certification in healing, praises Nicole's talent: "Her value as a medium in years to come will be enhanced by her feelings of love and compassion."[34] Just before I met Nicole, she had completed her training and earned certification as a medium from the Trilogy Institute.

Although mediums must be eighteen years old before they can practice at Lily Dale, their abilities may be recognized when they are much younger. Margaret Fox was fourteen when she first demonstrated communication with spirits; her younger sister Kate was eleven. Since these two very young women inspired Spiritualism's beginning, it does not seem surprising for a teenage girl to become interested in spirits. Like the Fox sisters, Nicole has received much media attention and many requests for readings.

"Have your friends understood about your readings?" I asked Nicole.

"Sure," she answered. "Sometimes there's some teasing, like, 'What will I eat for lunch?' but not much." It was good to hear that she had understanding friends. Outside her own group, she was rapidly developing a following as a reader at parties and other special events.

My own reading went well. Nicole told me that one of her own spirit guides was a Native American named Dove: "She's very tall, and she has blue beads. She has a tan vest on." My own main guide, she said, was a green man named Coy. The other guide, whom I could ask for help at any time, was the spirit of a woman named Joan. When she checked my aura, Nicole found that it was green, a sign of healing energy. She told me not to worry about health-related issues: "Spirit says that you don't have anything to worry about right now, but in the future you should pay attention to things." I did not have any specific health worries at that time and agreed that it was important to work on staying healthy.

Nicole Rose.

Health concerns have motivated many people to seek readings from mediums. During message services at Lily Dale, I had heard about various health issues. Berardi told me about a recent reading of Nicole's in which she perceived a man's illness: "She was giving a reading to a man the other day, and she thought she kept seeing red in the lower abdomen. He started crying his eyes out and he said, 'I found out I have prostate cancer yesterday.' She said, 'I see you with two or three months' treatment, and you'll be okay.'"

Nicole has already given readings for many people and will do more as she develops her talents. Her mother's forthcoming book, *The Man at the Foot of the Bed*, will offer more details about Nicole's work as a medium.[35]

CHAPTER 3

MYSTERIOUS MANSIONS

According to local legend-tellers, some of the loveliest mansions of the Southern Tier have permanent residents who are no longer alive: ghosts of their first owners that cannot bear to leave their beloved homes. Mansions that have become known as haunted places appeal to both young and older people. Some of the mansions' quirky features—peculiar dumbwaiters, dark passageways, sinister-looking portraits and ornate woodwork—suggest that a ghost might hover nearby. Learning about mysterious mansions' ghosts provides insight into nineteenth-century customs and gender roles—not only the parts played by male captains of industry but also those played by strong, influential women. Binghamton's oldest surviving mansion, preserved by Southern Tier women, reminds us to keep gender roles in mind as we listen to ghost stories.

PHELPS MANSION (BINGHAMTON)

Built in 1870, the Sherman D. Phelps Mansion preserves an important part of Binghamton's early history. At that time the railroad was still new, and people no longer depended on canals to move heavy materials to the Binghamton area. Phelps, an energetic entrepreneur who began his career as a traveling salesman, came to Binghamton in 1854 with his second

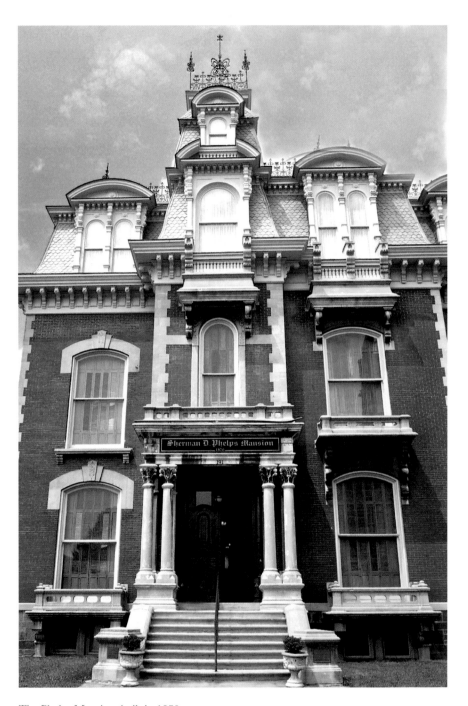

The Phelps Mansion, built in 1870.

wife. Eager to make his mark on the city, he got involved in many business enterprises. He accomplished so much that his life history has become a local legend, and his ghost has become a well-known resident of his splendid home.

According to Phelps Mansion docent Robert Keller, whom I interviewed in the summer of 2010, Phelps carried $100,000 in cash when he arrived in Binghamton. First he opened a bank; then he organized a cigar manufacturing business that exported over one million cigars per year. He also started a water company and an "illuminating gas company." His tanneries prospered, as did all the other businesses that he put together. This rapid accumulation of wealth was one of many American success stories in the late nineteenth century.

After achieving wealth and prominence, Phelps ran for mayor and won, but his margin of victory was very slight: just one vote. Many people detested Phelps because he was so self-centered. According to Keller, people viewed Phelps's massive home as "a monument to his ego." Phelps had hired Isaac Perry, one of the leading architects of that period, to impress everyone else in the community, and he certainly succeeded in doing so. Besides building the unique Phelps Mansion, Perry built other imposing buildings in downtown Binghamton, as well as the State Capitol building in Albany. Toward the end of his life, he designed the gates of Binghamton's Spring Forest Cemetery. His own funeral cortège was the first to go through the new gates: a fitting conclusion to a life of impressive architectural achievement.

Art historians have identified the Phelps Mansion's style as Second Empire or Neo-Grec, but neither of these terms fully describes its unique combination of classical elements. Each part of the house has distinctive woodwork by Orville Ronk: black walnut in the front hall and central staircase, rosewood and maple in the parlor and golden oak in the dining room. Besides these variations, each room has a different kind of fireplace. The parlor fireplace has sacred laurel leaves in steel and brass, while the dining room fireplace has carved fruits and fish. Over the mirror in the front hall are a cartouche with Phelps's initials—S.D.P.—and griffins for good luck. In the conservatory are tall mirrors and glass doors. And in a small room to one side of the front door, visitors can see Roman soldiers' heads on a gas-powered chandelier.

All of these elegant features express Phelps's pride in his mansion. Ghost stories about Phelps suggest that his pride makes it impossible for him to leave. Robert Keller, who is not only a docent of the mansion but also a trained medium, explains why Phelps won't leave:

Sherman Phelps has not gone over. He is what we call a hoverer. It seems to him that no time has passed since he died, but he can see things happening in his house. Now the things that he does sometimes can be very strange. He will take candles out of candleholders and put them this way on top of the holder [horizontally], *and if you try to do that yourself you cannot do it. He doesn't like people in the house, especially when we get big crowds, which we have had in the past; we've had hundreds and hundreds of people. He doesn't like that.*

Keller's story makes it clear that Phelps plays tricks for a reason: he dislikes having strangers in his house and wants to scare them away. Along similar lines, Keller describes a shocking moment when a woman saw a heavy object jump out of one of the fireplaces: "There are eight fireplaces in the house. One of them has bars of bronze, with knobs, and then there are little extra branches, and one of those flew out and landed on the floor. Now if you were to lift that thing, you'd see it's a good two or three pounds."

How could such a heavy bar fly out of the fireplace by itself? We might guess that Phelps was trying to proclaim his presence and frighten the daylights out of the woman who was sitting by the fireplace. Other signs of his presence have come in the form of elevator movement and unexpected sounds. Keller offers some details from other museum staff members' and his own experiences:

People claim he's going up and down in the elevators all the time. I think [Phelps] *thinks it's a toy. The house managers are there all the time, and often their dogs will bark when there's nobody in the house, and they will hear footsteps. One day I was there; I was polishing some little medallions on some antique chairs that are brass. I was the only one in the house, and upstairs I heard voices quite loud and doors slamming.*

Like other New York ghost stories, this one describes a sensitive animal and a playful, capricious ghost. Loud voices, the sound of doors slamming and other pieces of sensory evidence show that Sherman D. Phelps is enjoying an active afterlife.

The Phelps Mansion's original owner was a determined, house-proud man, but the mansion survived through the efforts of determined women who founded the Monday Afternoon Club in 1890. In those

Candles that a docent says were disturbed by the Phelps Mansion's ghost.

days, women needed their husbands' help to get mortgages. With the help of their husbands, the founding mothers of the club became the mansion's owners. In 1905, they added a ballroom that became a popular location for high-society gatherings. Currently known as Mondays at the Museum, the club has saved the Phelps Mansion from the kind of deterioration that has afflicted other nineteenth-century buildings. Many of the mansion's female supporters have been active supporters of the local community. Among them was Roberta King, an English teacher at the American Civic Association who passed away there in the mass shooting of 2009. King's collection of beautiful antique dolls now adorns the mansion, reminding visitors of her devotion to education.

ROBERSON MANSION (BINGHAMTON)

Thirty-four years after the Phelps Mansion's construction, Alonzo Roberson Jr. commissioned architect C. Edward Vosbury to build an Italian Renaissance Revival mansion on Front Street. Born in Binghamton in 1861, Roberson belonged to an affluent family whose business ventures had prospered. With his wife, Margaret Hays Roberson, Alonzo Roberson planned a splendid home with all the latest conveniences and luxuries. Among these special features were an elevator, an intercom system, central heating, combined electric and gas lighting and a dumbwaiter. Each bedroom had its own bathroom. On the third floor were a billiard room and a ballroom. There was a separate building for servants' quarters, a stable and other outbuildings.

Like the Phelps Mansion, the Roberson Mansion has distinctive woodwork in each room on the first floor. Its grand central staircase stands next to a set of remarkably fine stained-glass windows. Stretched damask on the walls of two first-floor reception rooms gives the mansion an especially elegant appearance. The home's wrought-iron fence and landscaping also contribute to its beauty. In 1907, after all of these features were complete, the Robersons moved into their new home, which they enjoyed together until Alonzo's death in 1934. His will provided an education center after the death of his wife. In 1954, the Roberson Memorial Center opened its doors to the public. It is currently known as the Roberson Museum and Science Center.

Since 1954, the Roberson Mansion has welcomed countless visitors. During the winter holidays, museum staff members have decorated one downstairs reception room as a children's room, with gifts all around. They have also invited local model train enthusiasts to keep a train set running on the mansion's top floor. Because of these special holiday additions, many children have trooped through the mansion's hallways. Children and adults have also enjoyed the elaborate Halloween decorations that have sometimes festooned the mansion. Laughter and squeals of excitement are familiar sounds at that time of year.

According to local ghostlore, not all of the children who run through the mansion's rooms and hallways are alive. In the fall of 2007, one of the mansion's receptionists told me about an uncanny experience:

Roberson Mansion, completed in 1907.

One night around Christmastime when I was in the museum after closing hours, I kept hearing the sound of children laughing. At first I thought maybe I was imagining it, but the noise wouldn't go away. After a while I couldn't ignore it anymore. I didn't understand where the noise was coming from, since the museum was closed. I walked down the hallway and followed the noise. When I came to the room where the noise was coming from, there was nothing there.

This story suggests a mystery: who are the child ghosts? Alonzo and Margaret Roberson had no children. The absence of children in their lives makes the presence of child ghosts all the more intriguing.

Staff members at Roberson have also told stories about the ghost of Alonzo Roberson. Eve Daniels, Roberson's curator of collections, kindly told me a number of stories about Roberson ghosts in the summer of 2010. Her stories describe staff members' own experiences since the early 1980s. Two stories from the 1980s describe what may have been the ghost of Alonzo Roberson:

Near closing time, one of our receptionists had gone up to the second floor to use the ladies' room. She noticed an older, balding man in the galleries, and she informed the Security Guard, who was doing his end-of-the-day sweep through the museum. When the guard went upstairs, he did not find anyone. Apparently the man's appearance resembled that of Mr. Roberson.

Within the new wing connected to the mansion, there used to be a theater (there are also galleries and the planetarium). During one of the evenings a crew was working on stage and they saw what they believed to be a man seated in the darkened back row. Being on stage with the very bright lights would have affected how much of the seats one could see. Upon further examination, no one was there. There was speculation that it may have been Mr. Roberson.

Both of these stories express ambivalence. Was Alonzo Roberson's ghost really present, or did he just seem to be there? Daniels herself has never seen or heard a ghost at her workplace, although she has been intrigued by reports of unusual happenings. It is interesting to hear of these two possible sightings of the mansion's first owner. Like Sherman D. Phelps, he seems to be a house-proud gentleman who does not want to leave his stately home.

Many of the ghost stories that Daniels has heard over the years do not involve the Roberson family. One of them takes place in an elevator, a familiar setting in *Twilight Zone* episodes and horror movies: "One co-worker got into the mansion elevator and she said it felt as though she had backed into someone, even though the elevator was empty. She said she felt the hair stand up on the back of her neck, and she got out of the elevator as quickly as she could." Backing into someone whom you cannot see is not a welcome surprise! Luckily, the story ends happily. The Roberson employee makes a quick exit, glad to escape from the invisible ghost.

Other intriguing stories told by Eve Daniels involve ghosts of soldiers. She recounts a colleague's uncanny experience late at night:

A co-worker was working late on an exhibit. It was about 11:00 p.m. and she was washing some paintbrushes out in a slop sink located across from our woodshop, which is in the mansion basement. There used to be a small mirror hanging over the sink, and she was not paying much attention to it or anything else. Her eye caught an image in the mirror. She described a dark-haired young man wearing what appeared to be a West

Point uniform. She described the double row of buttons on the jacket. When she quickly turned around, there was nothing there.

This spectral soldier wears an easily recognizable West Point uniform. Curious about early West Point graduates who lived in Binghamton, I did some research and found a military man who fit the ghost's description. Dark-haired General John Cleveland Robinson, born in Binghamton in 1817, attended West Point but did not graduate because he spent some time studying law. He fought in the Mexican-American War, the Seminole War and the Civil War. Two of the Civil War battles in which he fought were the Second Battle of Bull Run and the Battle of Fredericksburg. After losing a leg in the Battle of Spotsylvania Court House, he received a Medal of Honor. In 1872, he was elected lieutenant governor of New York. He died in 1897 and was buried in Spring Forest Cemetery. I do not know whether this war hero's face appeared in the mirror at Roberson late at night, but the apparition of a man in a West Point uniform certainly brings to mind this important figure from Binghamton's past.

Daniels also described some unusual things that happened deep down under the ground, in Roberson's storage vault:

> *One of my supervisors had gone into our underground storage vault. It has a main corridor with mobile shelving units on each side. She had been between one of the shelving units when she saw some black, shadow-type thing pass by in the central corridor. She said she had an overwhelming feeling of evil and dread, and she came upstairs immediately. A few of us had been working in the back work area upstairs, and when she came back to where we were, she was as white as a sheet and told us we were not to go downstairs alone, ever. Obviously, this policy did not last, but for a while, we were all a little on edge.*
>
> *Also seen in our storage vault—a Revolutionary War soldier with red hair and a red coat. We know that the Sullivan-Clinton campaign passed through here, but where this apparition came from—who knows?*

Both of these stories send a shiver down my spine. Underground vaults can be creepy places. The story of the "black, shadow-type thing" sounds frightening indeed. It is hard to define such a strange apparition, and its amorphousness contributes to its horror. The Revolutionary War soldier is easier to place. The Sullivan-Clinton Expedition of 1779 moved rapidly through the Southern Tier, laying waste to Native American villages.

Was a red-haired soldier among them on the banks of the Susquehanna River? We cannot know the answer to that question, but we know that this campaign took away the homes and livelihood of countless Native American people.

I have heard only one Roberson ghost story about a Native American. A friend who used to work at Roberson Center told me that sometimes, when she was alone, she could hear the soft sound of a woman singing. It was, she thought, a young Native American mother singing to her child. My friend enjoyed listening to the song, which was faint but very peaceful. Her description of the ghostly sounds reminded me of the Native American singing that people have claimed to hear near Sa Sa Na Loft's grave in Owego, mentioned in chapter one. In both locations, soft, melodious sounds remind listeners of the harmony that belonged to an earlier way of life among the Haudenosaunee people.

There are other Roberson ghost stories—perhaps enough for a whole book on that subject—but I will include just one more here. This story comes from my friend Maryanne White, who runs Roberson's Clayworks pottery studio. A very fine potter and a down-to-earth person, White does not usually bring up ghostly phenomena. She did, however, want to tell me about one unusual experience at her workplace:

> It was about two in the morning; I was in the studio by myself firing a big kiln. I was up front, and I just heard muffled women's voices, conversation going on. Can't tell you what they were saying or how many there were, it was just muffled voices. It was the carriage house, so the studio is where the horses were. I'm assuming that the upstairs were servants' quarters. Someone else—one of the other studio assistants—heard men's voices at three in the morning.

Like the story of a Native American woman singing, this one describes soft voices that are hard to hear. Many intriguing ghost stories involve soft sounds and momentary images perceived late at night. These are sensory impressions that bring the past back to us, just for a moment. Roberson Mansion and other stately homes that are open to the public help us remember the past in the midst of the present.

THE PINK HOUSE (WELLSVILLE)

One of the best-known mansions in the Southern Tier is Wellsville's Pink House. Built in 1868 by Edwin Bradford Hall, the Pink House dazzles its admirers with its Italian Renaissance architecture and elegantly landscaped lawns. Unlike the Phelps Mansion and the Roberson Mansion, the Pink House is a private home. In the summer of 2010, after seeing many photos of the Pink House, I finally got to see it. Such glorious pink paint! The house stands tall in its neighborhood, having been built on a grander scale than nearby dwellings. It is no wonder that the Pink House has become legendary in Wellsville and throughout the Southern Tier.

In his masterful study of New York ghostlore, *Things That Go Bump in the Night* (1959), Louis C. Jones analyzes Pink House legends in depth. He discusses Hanford Lennox Gordon's poem "Pauline" (1878), which the early settlers in Wellsville considered the true story of what happened in the Pink House. According to Gordon's poem, Paul and Pauline are young lovers separated by Pauline's wealthy father. After Pauline's father falsifies notes of betrayal that ruin their romance, Pauline gets engaged to another man, and Paul pretends that he has lost interest in her. The next morning, Paul's boyhood friend awakens him with terrible news: "Pauline, who was to be a bride to-day,/ Was missed at dawn and ere the sunrise found—/ Traced by her shawl and bonnet on the bridge,/ Whence she had thrown herself and made an end." Grieving and filled with remorse, Paul becomes a soldier in the Civil War and tells the whole sad story to his captain at the Battle of Appomattox. As he dies of his war wounds, his last words to his captain are "Pauline—how beautiful!"[36]

As Jones explains, there is much more to the Pink House legend cycle than the plot of "Pauline." Variants of the story tell of two sisters, one of whom becomes engaged to a handsome young man and marries him. The other, who has adored her sister's fiancé in secret, drowns herself in the Pink House's fountain or in a millpond. Thirty miles from Wellsville, people have told a more elaborate version of the legend, in which the young man elopes with his fiancé's younger sister. Heartbroken, the bride-never-to-be drowns herself in a swimming pool. Then, as found in Jones's *Things That Go Bump in the Night*, her ghost awakens her sister and her former fiancé as they lie in bed: "She threw back her head and with a quick movement she tossed her wet hair across their faces and drew it toward her before she vanished into the shadows forever."[37] This

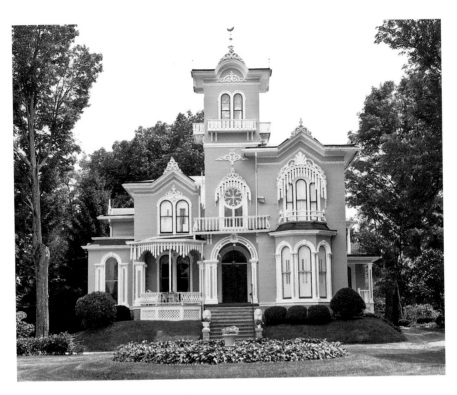

Pink House in Wellsville, built in 1868.

is a powerful portrayal of the wrath of a woman scorned. After the wet-haired ghost sweeps out of the young couple's room, their potential for a happy life seems virtually nonexistent.

The longest Pink House story in Jones's collection not only describes the jilted young woman but also explains what happens after she drowns herself in the Pink House's fountain. The young couple has a little daughter who brings them great happiness, but the ghost of the child's jilted aunt lures her into the fountain, where she drowns. Deeply saddened, her parents leave Wellsville, but later they return with their two-year-old daughter. Every night the parents put a candle in their child's room to scare away the aunt's ghost. The story concludes: "With candle-light replaced by gas, and then by electricity, an ever-burning light was maintained in the girl's room, where even to-day passers-by may see it, though the niece is nearing eighty, and her parents have left the Pink House forever."[38]

Having collected variants of the Pink House legend over the years, I can report that they have become simpler than the long versions that Louis

Jones included in his book. Most of the more recent variants focus on the lost child drowning in the Pink House's fountain, the outline of which is still visible on the house's front lawn. A middle-aged woman of German descent told this story in 2005:

> *Grandpa used to work on the Pink House and painted it three times. My mother told me that there was a ghost in the house, and she and all of her friends used to go trick-or-treating there to see if they could get a peek of what was inside. The house was built in 1868, and a small family bought the house shortly after, but one day their child came up missing and was found dead in the water fountain that was located in front of the house. People say that she went out wandering one night and drowned in the fountain. Nobody knows if this is a true story or not, but people say that it's haunted and at night some people see a ghostly figure staring out the window into the street. The house still remains within the family, and nobody has been able to get inside to witness the ghost of the child.*

This story and others make it clear that the Pink House has become a local monument. On Internet message boards, Wellsville residents reminisce about trick-or-treating at the Pink House. For both children and adults, this mansion represents past grandeur and current mystery. Some observers have described a ghostly figure standing in a window. Around Halloween, local residents rekindle their interest in possible ghosts. All year round, however, the Pink House inspires townspeople's pride in their historic community.

CHAPTER 4
HAUNTED HOMES

HISTORIC HOUSES (OWEGO AND VESTAL)

Not all haunted houses are huge, impressive mansions; some are modest homes, and others have served as commercial properties. No matter how old a home is and what architectural style its builder followed, there are certain factors that make haunting likely. One of those factors is sudden, untimely death; another is the living person's sensitivity to unusual experiences. Early records help us understand how sites of sudden death became known as haunted houses. Let us begin with two old stories: one from Owego and the other from Vestal.

The Owego ghost story comes from a manuscript written by LeRoy Kingman, who was born in 1840. Kingman explains that Judge Thomas Duane moved to Owego in 1800 with his wife, a widow of an officer in the Continental army who had died in the massacre in Wyoming Valley, Pennsylvania, in 1778. Judge Duane built a store on the bank of the Susquehanna River and painted it bright yellow. His stepdaughter, Polly Pierce, built a fine house on Hollenbeck's Eddy. After her death in 1815, the house belonged to several owners and became a tavern in the early 1830s.

At this point the house developed ghost story potential because river raftsmen and boat captains stayed there overnight, leaving their rafts and boats tied up in Hollenbeck's Eddy while resting and enjoying a few drinks.

One of these overnight guests was a riverboat captain named Butler, who had a very strange dream. His story follows:

> *One night previous to the day on which he was about to leave Owego on one of his periodical trips he dreamed that he fell overboard from a canal boat and was drowned. The dream made such an impression upon him that in the morning he narrated it to his wife. She was considerably affected, and endeavored to dissuade him from going away. He laughed at her fears and went on his way. A few days afterward she received information of his death, which had happened in every respect exactly as it had been presented to him in his dream.*[39]

After Captain Butler's drowning, nobody lived in the house where he had been an overnight guest. Townspeople called the dwelling a haunted house, claiming that they had heard noises coming from the house at night and seen lights shining in the windows. Others disputed these claims, suggesting that the sounds and lights came from "people of not particularly reputable character, who consorted there at night."[40] This unsolved mystery stopped bothering people once the old house was torn down.

Another mid-nineteenth-century building, the Drovers' Inn in Vestal, has gone from one identity to another. Two prominent Vestal citizens, John and Jacob Rounds, built and named the Drovers' Inn. When it opened in 1844, the inn welcomed drovers of cattle, pigs and turkeys who were following the Jamestown Turnpike. Crane's Ferry brought people across the Susquehanna River nearby, so the inn became a favored meeting place for travelers and local residents. Later, the building became a home for members of the Rounds family. In 1930, new owners converted it to the Ackley Funeral Home; then, in 1940, it became the Bowles Convalescent Home. In 1950, the building was divided into four apartments. In 1987, Bill and Linda Brock opened a restaurant, bringing back the traditional name the Drovers' Inn. In 2003, the Iacovelli family opened a fine new restaurant known as the Plantation House, which closed in 2008. Currently this beautiful Greek Revival building waits for a buyer.

In the fall of 2007, four students from my Folklore of the Supernatural class—Lindsay, Hali, Kirsten and Holden—investigated the Drover's Inn's ghost stories with the kind permission of the Iacovelli family. They were thrilled to discover that the inn had at least one ghost. The bar manager explained, "Females see the ghost. Or at least those are the only

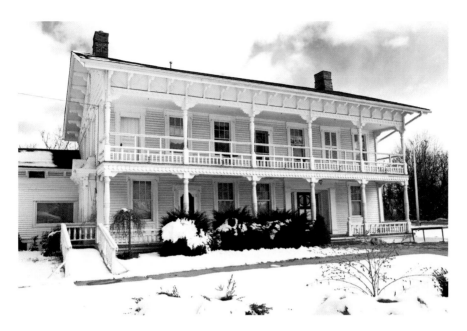

The Drover's Inn in Vestal, built in 1844.

people that admit to seeing the ghost." He went into more detail about ghost sightings:

We think [the ghost] *is the woman in the painting hanging in the front hallway. She wears a large hat and a long hoop skirt. This ghost has been spotted in the dining room on two occasions: both by women, both on a Monday night, and both were being waited on by the same server. Another sighting occurred in the bathroom, which is said to be haunted, as well as certain areas of the dining hall. A young girl went to the restroom and saw the ghost standing inside. She said that the ghost reached out to touch her and then disappeared.*

The clothing of this elegant female ghost places her in the second half of the nineteenth century. Since most of the visitors to the inn in its early days were men, the beautiful nineteenth-century lady seems to belong to the time when members of the Rounds family frequently went in and out of the building. Intriguingly, the ghost only communicates with women. Does she distrust men or simply prefer women's company? Sightings of the ghost have become part of the inn's appeal; although the Plantation House

restaurant is no longer open, one can still find enthusiastic comments about the ghost's presence on Tripadvisor.com.

The Plantation House's owner told my students that a female ghost had made her presence known to men by walking by them. During the restaurant's construction, he said, something strange had happened:

> *One Wednesday night, I was in the kitchen with my buddies around ten. We heard the front door open, but we weren't open for business or anything. Then we heard footsteps, probably a woman's footsteps since it sounded like the clicking of high-heeled shoes. We looked all over the building: in the basement, upstairs, every dining area, everywhere. We couldn't find anything at all.*

Whether this was the same female ghost that appeared in the dining room and bathroom was not clear, but the owner thought that the two might be the same. He mentioned that the inn's ghost or ghosts had become a scapegoat for the staff; whenever a plate dropped or lights went out, staff members blamed the ghost. None of the staff members thought the ghosts were unfriendly; they viewed the ghosts as playful tricksters.

Visual evidence can be very persuasive. The owner told my students a very interesting story about what happened when a photographer took a group photo on the restaurant's front porch:

> *There was one time when there were people here dressed up in clothes from the Civil War era. They all stood in front of the restaurant on the porch and took a picture. Most of the pictures came out fine, but one of them was foggy. Everyone came out clear in the back rows, but the front rows were blurred, and a lot of spiral orbs filled the front rows of faces. It was really cool.*

It seems delightfully ironic that the "real" Civil War folks might be there in the picture, blurring faces and creating spiral orbs. Whether or not these images signal a supernatural presence, they remind us of the borderline between the past and the present.

ETERNAL OWNERS (BINGHAMTON AND APALACHIN)

Some of the Southern Tier's haunted homes date back to the late nineteenth century, when architects specialized in designing ornate Victorian houses. One such house is Binghamton's The Gables, built in 1894, a six-family dwelling with five gables and two chimneys. The Gables is not one of the Southern Tier's grandest or most elaborate buildings, but it is certainly one of its historic treasures. Located near Recreation Park, The Gables has provided comfortable lodgings for Binghamton University students. English majors have especially enjoyed this house, whose name resembles the title of Nathaniel Hawthorne's novel *The House of the Seven Gables*.[41] Salem, Massachusetts's House of the Seven Gables functions as a museum that draws crowds of tourists with an interest in macabre events of the past. Binghamton's "House of the Five Gables" does not attract visitors the same way, but its story definitely sends a shiver down the listener's spine.

Here is the story told by my student Bev in 1978:

> *I called up my landlord and asked him if he could show me any pictures or other old stuff about The Gables. He said he'd be glad to bring some pictures and would come over later.*
>
> *Since I had some time on my hands before my landlord was coming over, I decided to go up to the attic. I'd never been up to this house's attic before. When I got up there, I turned on the light, a bare old bulb. It was incredibly dusty up there. I started digging around in an old trunk and found some old clothes but nothing that looked interesting.*
>
> *Then suddenly I heard a sound and looked up. Off to one side I saw the head of an old man floating in the air. He looked really serious and had half-closed eyes. I blinked to see if the old man would go away, but he didn't. I ran down those stairs pretty quick!*
>
> *I went down to the kitchen to calm myself down and get some coffee. After a while, my landlord came over. He spread an old photograph album out on the kitchen table. "Look," he said, "This is a picture of the man who first lived in The Gables." It was the same old man whose head I saw up in the attic!*

Like the ghosts of Sherman D. Phelps and Alonzo Roberson described in chapter three, this man stays active in his old home. Unlike those two

famous industrialists, however, he is not famous. He seems proud of The Gables and eager to help a university student learn about its history. In Southern Tier ghost stories, this kind of revelation happens fairly often. The sudden appearance of an image in a mirror, outside a window or elsewhere shows that someone who once lived in a dwelling has stayed there. Louis C. Jones, the distinguished scholar of New York ghostlore, saw his father sitting in the barn of his home in Albany shortly after the father's death in 1941. In *Things That Go Bump in the Night*, Jones explains, "He looked up at me, his beard white and gleaming, but his pale blue eyes were more cold and expressionless than I had ever seen them."[42] A devoted gardener, his father was sitting on a crate cutting peony roots. Attributing this image to memory, sadness and fatigue, Jones did not claim that his father's ghost had actually appeared—but it was clear that the experience was very important to him.

My student Aaron collected a similar story from his mother, a resident of Apalachin, a few years ago. Aaron's mother vividly recalled her husband's account of a startling encounter in his family's old house when he was a boy:

When Dad was about ten or eleven, he came home from school one day to an empty house. He put his stuff down and eventually went into the bathroom. He stood in front of the sink to wash his hands, and as he was rinsing, he looked up at the mirror and saw an old, old man in the mirror. He flung around, but no one was there.

He was so scared, he ran outside. Grandma came home shortly after, and seeing Dad outside, asked what was wrong. He told her what happened. She asked him to describe the man and when he did, she said it was the man whose house it had been, and he'd died there. This happened in the sixties.

After washing and rinsing his hands, the boy looks up and sees an "old, old man" in the bathroom mirror. What a shocking sight! When we look at mirrors, we expect to see ourselves, not frightening images of other people. There are, however, old European traditions of seeking spirits in mirrors. Young people may look for the face of a future spouse, but if they act vain, they may see the devil's face peering at them. Bill Ellis's *Lucifer Ascending* (2004) offers intriguing details about American mirror gazing rituals, which had a close connection to Halloween in the early twentieth century.[43] The "Bloody Mary" ritual of summoning a witch

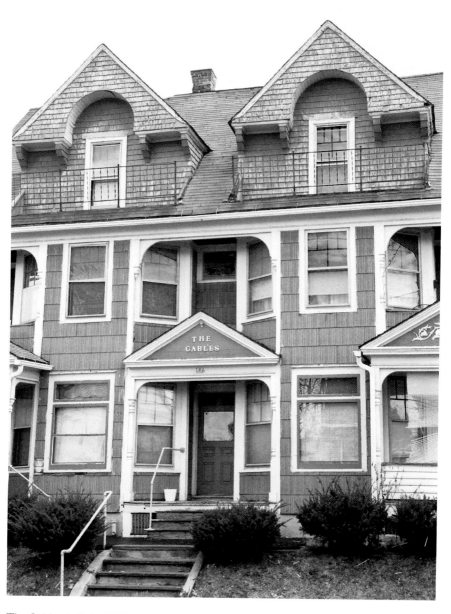

The Gables, built in 1894.

Haunted staircase of a Binghamton home built in 1897.

in a mirror began in the 1960s. Perhaps the boy who suddenly saw a face in the mirror had learned about the "Bloody Mary" ritual from friends. In any case, the sudden sight of an old man's face startled and frightened him. After his mother told him that this was the face of the previous owner who had died in the house, he knew that he had had a close encounter with the spirit world.

Not all haunted house stories describe scary encounters; some examine close relationships that continue after death. One of my favorite ghost stories comes from friends who live in a beautiful Victorian house on Riverside Drive in Binghamton. This house, built in 1897, has had several renovations, but its central staircase has stayed the same. Since the 1970s, I have heard several stories about a ghost that trudges up this staircase late at night. Here is one version of the story that my friends told me:

> *The man who used to live in our house loved his wife very much. When they got old, his wife became an invalid. Because cold drafts bothered her on icy winter nights, her husband kept a small fire going. Each time the fire ran out of wood, he would go downstairs to get more. He was getting old, so he moved slowly, but he always kept the fire up.*
>
> *We've heard footsteps on the stairs on cold winter nights. They're especially noticeable when ice covers the streets and sleet hits the windows. Late at night or early in the morning, we've heard slow, halting footsteps going upstairs. It's just the man who lived here before, taking care of his sick wife. We've never been afraid of him.*

This touching story expresses the traditional motif E337, "Ghost reenacts scene from own lifetime," one of many ghost story elements that Stith Thompson chronicles in his *Motif-Index of Folk-Literature* (1966).[44] After his death, the devoted husband keeps going up the stairs that he has climbed every night, bringing wood to keep his dear wife warm. The story suggests that love transcends death, continuing indefinitely. No wonder the people who have lived in this turn-of-the-century house have never feared their resident ghost! He is a loving, hardworking man who will not let death stop him from taking care of his wife. He reminds me of Orpheus, the Greek hero who loves his wife so much that he follows her into the realm of death.

Sensitive Children and Playful Child Ghosts (Olean and Owego)

Some haunted house legends suggest that children communicate with ghosts better than adults do. Because they are more innocent and open-minded than adults, children may seem to be the best receivers of spirits' messages. In chapter two I mention Nicole Rose, a young medium in Horseheads. During my years in this area I have gotten to know several young women who felt close to spirits as children; I have also heard about boys with a similar inclination. Phil Jordan, a well-known medium who lives in Candor, discovered his psychic abilities at the age of sixteen.[45] For many years, he has given individual and group readings for Southern Tier residents.

With the help of my student Leah, I recently learned about a little boy in Olean who enjoyed talking with the deceased owner of his Italian American family's home. This boy, the brother of Leah's friend Gina, had an unusual talent for spirit communication. Gina's story follows:

Once my little brother started talking, he talked about his friend Frank. He kept talking about Frank; I think it was his first word, his first or second word. And they didn't know what he was talking about with Frank; he didn't understand, nobody could understand. So anyway, my stepmother goes to this psychic [in Lily Dale], *and she says that there was a guy that died. It was like, an elderly couple and the guy was painting in the driveway on a ladder and he fell and he died, because he was older and he fell. And the woman eventually ended up selling the house because she didn't want the big house all to herself.*

So the psychic told us that his name was Frank, and she told us that he had some things to say to us. First, he thinks that my little brother is an outstanding person and he communicates with Frank. And he also said something that was really strange; he said, "I'm glad that you guys keep the cabinet that I built and I'm glad that you put it in the kitchen," which was weird because it was in the basement. This old grungy cabinet: my dad found it and he fell in love with it, and he stained it and put it in our kitchen. So the psychic really had no way of knowing that we put the cabinet in our kitchen, and my stepmother went home and did some research about the people that lived in the house before us. Their names were Frank and Marsha, and he did die in our driveway. And to this day my little brother still talks about Frank.

Gina's story begins with a small boy's invisible friend and ends with a revelation from a psychic at Lily Dale. The psychic's message identifies two key facts: Frank's co-ownership of Gina's family's house and his fondness for a cabinet that now stands in the family's kitchen. How could the psychic know such specific information? It seems that Frank's spirit has reached both the little boy and the psychic, offering information that Gina's stepmother later confirms. Like the loving husband in the house on Riverside Drive in Binghamton, Frank cares about others, but instead of doing the same thing repeatedly, he forms a friendly relationship with a sensitive child. As far as we can tell, Frank's haunting of the house pleases the current owners. They enjoy knowing some details about their friendly ghost and value their connection to the Lily Dale psychic.

My student Irene collected another story involving children from Marie, a fifty-seven-year-old South Owego resident, in 2004. At that time, Marie lived in a farmhouse that was more than one hundred years old; the house had burned down many years ago. As Marie explained, it took her some time to understand the impact of that long-ago fire:

> *When my boys were four or five years old they shared a bedroom in our home that was probably a hundred years old. It was the middle of the night and for no reason at all, their little record player started playing a record. It was loud, really loud. So we jumped out of bed thinking the kids were playing with their toys. But when we went in the room, the boys were sound asleep. It left us pretty dumbfounded, because there was no explanation for why the record player would be on; it had an arm that you had to pick up and put on the record. After we had turned it off and started to go back to bed, we noticed that the closet door in the bathroom was open. There were other things that happened, and the closet door was always open when they did. I asked my mother-in-law, who had lived in the house before me, if anyone had ever died in the house. And she amazed me by saying yes, the house had burned to the ground once and a little boy had died. I forgot to mention that we're also sitting on an Indian burial ground here.*

In Marie's story we find both children and a child ghost: apparently the little boy who died in the long-ago fire. The spirit of this little boy just wants to play; he hides in the children's closet and comes out to play tricks when the parents are not in the room. Although Marie does not mention communication between the two young boys and the boy ghost, the ghost

likes to stay close to the children. Turning on the record player signals his presence: "I'm here, ready to play!" His presence in the closet seems more sinister. For children, closets can be scary places where ghosts and monsters reside. Another worrisome subject arises in the last phrase: "we're also sitting on an Indian burial ground here." As I found while researching my book *Haunted Halls*, legends about Native American burial grounds remind people of the unjust displacement of the land's original inhabitants. Perhaps the child ghost is a Native boy who wants Marie's family to remember what happened to his people. Beneath the surface of this intriguing story lies the fact that the Sullivan-Clinton Campaign removed Native Americans from their ancestral lands in 1779.

THE SCENT OF ROSEWATER (OWEGO)

Southern Tier homes have a number of child ghosts but relatively few ghosts of women. Surely women's spirits deserve to be remembered as much as men's spirits do, but gender roles of past years have influenced the portrayal of ghosts. During the nineteenth century, men held many positions of power in the Southern Tier. As I mention in chapter three, women of the Monday Afternoon Club had to ask their husbands to help them buy the Phelps Mansion in 1890. Since then, gender roles have evened out considerably, but ghost stories remind us that this was not always the case.

There are, however, some intriguing Southern Tier ghost stories about female spirits. Besides the elegant lady of the Drover's Inn, there are others that deserve attention. Here is a story that my friend Maryanne White told me late one hot evening in the summer of 2010:

> There's a house in Owego where the owners used to see a woman in Victorian garb. Every time they saw her, they smelled rosewater. After seeing her several times, they took down a wall next to the spot where she'd appeared. Under the wall, they found a bottle of rosewater. Since then, they've never seen the woman or smelled her rosewater scent.

Rosewater, a light floral scent, was favored by women in Victorian times. Why would someone hide a bottle of rosewater under a wall? This burial of a perfume bottle sounds like the beginning of a mystery. Could an angry

lover have killed the woman and then buried her favorite perfume to remove evidence? Many traditional ghost stories focus on injustices that should never be forgotten. Some of these injustices happen when relationships go wrong. The motif EE334.2.3, "Ghost of tragic lover haunts scene of tragedy," is one of the oldest and most powerful of the elements of ghost story telling. Although we will probably never know what happened to the woman who left behind her bottle of rosewater, we can pay our respects to her by remembering her story.

HAUNTED COLLEGES

The Southern Tier's colleges and universities provide unique settings for telling ghost stories. Old gates, statues, fountains, lakes and, above all, buildings—residence halls, libraries, classroom buildings and office complexes—connect to campus legends and rituals. There is a sense of magical possibilities on college campuses, where young people eagerly seek exciting and rewarding experiences. When I did the research for my book *Haunted Halls: Ghostlore of American College Campuses*, I discovered that ghost stories build a sense of community on college campuses. They initiate students into college life, help them adjust to academic and social challenges and make the academic world more mysterious and thrilling.

ELMIRA COLLEGE

One of the most spirited institutions of higher learning in the Southern Tier is Elmira College, which has a long, proud history. Founded in 1855, Elmira was the first college to give baccalaureate degrees to women. Statues of Mark Twain (Samuel Clemens) and his wife, Olivia Langdon Clemens, adorn the center of the campus. Olivia Langdon graduated from Elmira College in 1864; her father was a member of the college's board of trustees. Twain wrote some of his best-known books at Quarry Farm near the campus. His

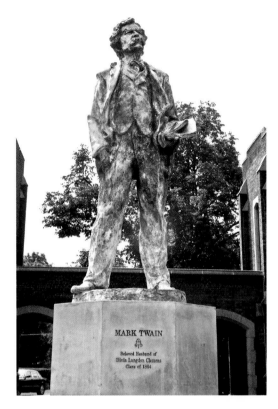

Left: Statue of Mark Twain at Elmira College.

Below: Mark Twain's octagonal study at Elmira College.

octagonal study now stands near the lake at the college. In the summer, a friendly and knowledgeable student guide sits in Twain's study, ready to answer visitors' questions.

Throughout the Elmira campus, visitors can see proof of Elmira College's exuberant spirit. The college's colors are purple and gold; an iris is its official flower. In the spring, purple irises and golden daffodils bloom. Another proof of campus spirit emerges late at night, especially around Halloween, when older students tell younger ones about the strange events that have happened in their residence halls. Tompkins Hall, an all-female residence hall built in 1928, has some of the best stories. Stella, a resident assistant on Tompkins's fourth floor, shared information about her building's ghost stories with my student Kelly in the fall of 2005:

> *The girls living in the lounge bedroom had a few sleepless nights in the beginning of the semester. Residents of the room had come to her terrified when they saw their posters on the walls had been taken down and rolled up. One of the residents' Bibles had moved across the room when she had stepped out for a minute, although she did not see it move. All this was blamed on an apparition named Mary. When residents are feeling down and depressed, Mary will come to them, although not so they can actually see her. The girls have felt her come and sit next to them, patting their heads in comfort. Rumors say that when students turn out the bathroom light and stare into the mirror, Mary will appear behind them.*

Stella's story portrays Mary as a kind, friendly ghost who enjoys playing tricks but excels at comforting sad students. Invisible but ever-present, she pats the heads of students who need comfort. Part of Mary's legend is the belief that a picture of her once hung in the fourth-floor lounge. She is such a beloved figure in Tompkins Hall that some students say "goodnight" to her every night.

There is, however, a dark side to Mary. If you stare into a mirror, she will appear behind you. Anyone who has performed the "Bloody Mary" ritual, repeating "Bloody Mary" or a similar name to summon a witch-like figure in a mirror, knows that mirror apparitions can be dangerous. Many college students in New York State have experimented with the "Bloody Mary" ritual late at night, usually in residence hall bathrooms. This ritual can be traced back to early European rituals for summoning a lover's or the devil's face on a reflecting surface, as I discovered when researching my article "Ghosts in Mirrors" (2005).[46]

Tompkins Hall at Elmira College.

While Kelly and the rest of the students in her research group were visiting Tompkins Hall, the hall's resident director showed them the room allegedly haunted by Mary. Kelly describes what happened:

We went up and down corridors, into a very rickety, old-fashioned elevator, and finally made it to the haunted room. Unfortunately for us, we visited on Friday, November 18, the week before Thanksgiving, so the majority of the residents in the building had gone home for their break, including the inhabitants of the lounge-bedroom. When Matt knocked on their door, it opened on its own, about six inches, with nothing but darkness staring back at us. Of course, without the girls there, we could not go in, so he shut the door…It was not until later when listening to [the recording of] *our visit that, quite distinctly, soft, low brass chamber music was playing in the background. The music was only playing for a short time, and only when we were next to this room. It started with the RD saying "Here's the room" and ended when we walked away. I like to think it was Mary's way of saying "Hi!"*

Another ghost of Tompkins Hall's fourth floor is a Blue Nun. Stella, the fourth-floor RA, explains:

> *The Blue Nun started out as a painting that hung in the lounge bedroom. In spite of the numerous times the room has been painted, the place where the painting once hung will not take new paint, always leaving the old outline behind. The Blue Nun was the aunt of a girl who once was a student at Elmira College and occupied that room.*

This colorful ghost seems exciting but a little creepy. Related to a former student at Elmira College, she belongs to the college family. But why does she haunt Tompkins Hall? Some versions of the Blue Nun story suggest that she awaits her niece or sister, who tragically died on campus; others suggest that the Blue Nun's room must remain closed because she needs plenty of space and privacy.

SAINT BONAVENTURE UNIVERSITY

Another high-spirited academic institution is Saint Bonaventure University, founded by Franciscan friars in 1855. Nicholas Devereux, a landowner from Utica, donated the land for the new college; he also founded the town of Allegany. One of the most impressive buildings on campus, Devereux Hall, honors the landowner who made it possible to start a center of Franciscan learning in the hills of western New York. Construction of "Dev," as it is fondly called on the Saint Bonaventure campus, began in 1926. Built in Italian Transitional style with a Spanish tile roof, Devereux Hall is the second-oldest building on campus and the oldest residence hall.

A well-known religious leader who lived in a room on the second floor of Devereux Hall was the Trappist monk Thomas Merton, who taught English at Saint Bonaventure from the fall of 1940 to the winter of 1941. In his memoir *The Seven Storey Mountain* (1948), Merton explains that he worked harder during his sojourn in Devereux than he had "in all the rest of [his] life put together."[47] During this period of a little more than one year, he discovered his vocation as a Trappist monk with the help of fellow faculty members and the director of the university's library. After Merton's

departure, students began to call a heart-shaped bare spot on a nearby hill "Merton's heart." According to a campus legend, all of the trees there fell down when Merton died; actually, however, oil drillers removed the trees in the 1920s. While Merton's room in Devereux Hall has not drawn visitors seeking ghosts, the building's fifth floor has attracted much interest.

In 2006, I learned the following story from Jake, a Saint Bonaventure student:

> *A group of kids were trying to conduct a spell or séance on the fifth floor. They were trying to raise some kind of spirit. When they were doing this a priest walked in and stopped the spell they were doing. Now the floor is haunted with evil spirits because the kids never finished the spell. Now the doors to the floor are boarded up, and it is forbidden that students go up there. It is also said that a few priests have gone up there to try to get the spirits out of the dorm but they couldn't, because when they got close they were so overwhelmed with the negative vibe that was coming from the floor that they had to leave immediately.*

Jake's story is one of many versions of Saint Bonaventure's most famous ghost legend. Saint Bonaventure's archivist, Dennis Frank, has kept excellent records of the black mass legend and others on the website "Legends and Myths of SBU." On this website he shares information from his interview with Father Alphonsus Trabold, a friar and professor who taught a course on paranormal activity from the early 1970s up to the time of his retirement. According to Father Alphonsus, no black mass occurred in Devereux Hall, but "the students could have been attempting to conjure up some type of spirit out of curiosity or eagerness to break some type of rule."[48]

Saint Bonaventure's black mass/exorcism legend circulated after the movie *The Exorcist* came out in 1974. In *Haunted Halls*, I discuss similar legends on the Georgetown and Fordham campuses. Near Georgetown in Washington, D.C., students visit a sinister-looking flight of stairs that they call the "Exorcist Stair." Fordham students talk about a resident assistant's encounter with a spirit that piles mattresses up against a wall until a ghostly priest comes to take care of the problem.[49] All of these legends express students' concerns about disruptive and dangerous spirits; they also add some excitement to everyday life on campus.

A different Saint Bonaventure legend tells of a more common problem: a paper that a student must finish quickly in order to get a good grade.

Devereux Hall at St. Bonaventure University. *Courtesy of Dennis Frank, St. Bonaventure Archivist.*

Dennis Frank's website describes a student who frantically tries to finish typing his paper late at night on the third floor of De La Roche Hall when a fire suddenly breaks out. Unable to stop typing and escape from the building, the student perishes. Some students believe the student's ghost haunts the third floor of this classroom building where a light shines late at night. Maybe the student is still working on his paper, or maybe he has finished it and wants to find its charred remnants.[50]

STATE UNIVERSITY OF NEW YORK AT FREDONIA

Located on the western side of the Southern Tier, the State University of New York at Fredonia has an outstanding education department and other programs that appeal to students throughout New York State. Many Fredonia students enjoy visiting the nearby Spiritualist community of Lily Dale and enjoy telling ghost stories. When Halloween approaches and chilly winds blow the last leaves off the trees, older students tell

freshmen about the ghost of Jimmy Igoe, who haunts the hall that bears his name.

Not all ghost stories have a foundation in fact, but unfortunately, stories about Jimmy Igoe are related to an actual tragedy. On June 5, 1970, Jimmy, a Fredonia student, went fishing on Lake Erie and drowned. Saddened by the loss of their friend, his fellow students insisted upon naming the campus's new dormitory Jimmy Igoe Hall. Ever since then, residents of Igoe Hall have talked about strange signs of Jimmy's presence: doors that slam, televisions that go on and off and elevators that go up and down without anyone pushing their buttons. Has Jimmy become a permanent resident of his own building? Some stories suggest that he scares students fairly often, especially around Halloween.

A 2004 story from Sandra, a senior at Fredonia, describes an alarming incident in Igoe Hall during her sophomore year:

> One night, my friend Becca came knocking on my door, and when I opened it she looked terrified. I asked her what was wrong, and she told me she thought a ghost was in our building and she had heard it. She had gone to bed and was trying to fall asleep when she heard these loud noises coming from her ceiling as if someone from the room above was moving their furniture around. This scared her, because there was only one girl that lived in the room above, and that girl had already gone home for the weekend. I went back to her room with her, but I didn't hear any sounds of furniture moving. Becca was still really scared, though, and so she spent the night in my room.

Sandra's story includes a motif that often appears in college ghost stories: E599.6, "Ghosts move furniture." Most of the "moving furniture" stories in my collection came from resident directors or resident assistants who were alone in their rooms at night, certain that nobody was in the room above them. Sharp, startling sounds late at night can be very frightening. In Igoe Hall and other buildings with a reputation for being haunted, such sounds seem to confirm the ghost's presence.

Another story about Jimmy Igoe's ghost moving furniture appears on Facebook, one of the most lively story-sharing arenas in this electronic age. The Facebook group "Jimmy Igoe—Fredonia's Eternal Student" presents multiple postings from current and former students who believe that they have encountered Jimmy's ghost. One of these students is Ryan Clapper, who posted several messages to the group's site in the fall

of 2010. His most interesting story describes what happened after he and some friends put on a Halloween haunted house program in Igoe Hall's basement. After the program's successful conclusion, Ryan and his friends went upstairs, where they discovered a startling sight:

> *The* [Halloween] *haunted house went off without a hitch and everyone loved it. Afterwards we went up to the suite, but shockingly, tons of furniture had been piled in front of the door and filled half of the rec room. Stacked floor to ceiling, tables and chairs that were nowhere around before now blocked the door to "his" room. There was about 2 hours between when we first went up there. There are tons of possibilities of how this could have happened, but it is unlikely that that amount of furniture was stacked there by students, up 2 levels. I know it sounds impossible and I wouldn't really believe it or would explain it away somehow if I hadn't seen it for myself.*[51]

Ryan eloquently expresses his belief in Jimmy's ghost having piled up the furniture, while stating that other explanations could be given. How could anyone have piled so much furniture up around the door to "Jimmy's room" in just two hours? Students are well known for their love of prank-playing; even I, as a freshman at Mount Holyoke, moved lounge furniture around to play a trick on friends. It would, however, take much time and effort to pile up "tons of furniture." Part of this story's appeal comes from its openness to different kinds of thinking. Those who believe in ghosts can take the story as an affirmation of Jimmy's presence and love of tricks, while others can offer more rational explanations.

BINGHAMTON UNIVERSITY

As an English professor and faculty master in two residential areas at Binghamton University, I have interacted with countless students, some of whom have generously told me great stories. I have chosen three meaningful stories to share here. The first shows how students from diverse cultural backgrounds enrich a campus's ghostlore, while the second and third offer moving examples of consolation after a tragic loss.

Binghamton University's ghostlore has grown as students from different parts of the world have told stories about supernatural experiences. Chinese, Japanese, Vietnamese, Thai, Filipino and Korean students have shared stories with me that reflect the richness of Asian folklore. Here is a story from Sang-hee, a Korean student, told in the fall of 2004:

> *During my freshman year I was hanging out with my friend in her room, and a Korean girl told me a story about a little girl who stands behind you when you shower. She starts to count all the hairs on your body, and if you're not done showering by the time she's done counting, she kills you. At first I was so scared that I took fast showers, but now I live in a suite with its own bathroom. I forgot about the little girl, and I take two-hour showers. Obviously, this isn't true. I'm still alive!*

Even though Sang-hee insists that the story of this dangerous ghost *"isn't true,"* her memory of short, nerve-wracking showers shows how much the story scared her. Bathroom ghost stories in Asia, the United States and other parts of the world emphasize how vulnerable a young person can feel alone in a bathroom. Korean children's folklore has several homicidal bathroom ghosts, including one that asks, "Do you want blue or red toilet paper?" If the victim chooses blue toilet paper, the ghost will strangle him or her, but if the victim chooses red, he or she will get stabbed. Legends of this kind have no happy ending!

There is, however, more to Sang-hee's story than the common fear of being alone in a shower stall. When Sang-hee heard her friend's story during her freshman year, she was struggling to adjust to daily life in an unfamiliar place far from home. In these circumstances, the idea of a ghost counting body hairs seemed especially horrifying. Her story reflects the anxiety of the transition from home to college, which all of us who have gone away to college have experienced to some extent.

Sang-hee's story describes a ghost with no known basis in fact, but some other Binghamton University ghost stories tell of students and staff members who once belonged to the campus community. One such story is "The Ghostly Gardener of Susquehanna," which explains the sad loss of a member of the maintenance staff at Susquehanna Community. Since this story came to me as several brief descriptions, I will summarize it here. John Mangino, one of Susquehanna's most popular staff members, always took a special interest in helping students. One day he suddenly fell ill while working and passed away in Brandywine Hall. After his death, students noticed plants and

flowers appearing in unusual places. One evening, resident assistants on duty in Brandywine received a plant that had no card attached to it. Could the plant's sender have been Susquehanna's ghostly gardener? John Mangino's kindness and concern for others continue to make young people's lives more pleasant, especially around the winter holidays, when the funds raised at an annual golf tournament in his memory provide gifts for local children.

My third BU ghost story explains the history of Moe Loogham. In the early 1970s, when recreational drug use was increasing, students created this legendary figure: a kind, generous drug dealer who would share his supplies with anyone who wanted them. Legends about Moe explained that he had left town but planned to return with drugs beyond students' wildest dreams. Through the early 1980s, students scrawled signs that said "Moe is coming!" and speculated that little black dots over doorways meant Moe would be arriving soon. Then legends about Moe became less common; only the DJs at the campus radio station told stories about his return, which represented the countercultural spirit of the sixties and the excitement of good radio shows.

On September 11, 2001, terrorists' attack on the World Trade Center in New York City resulted in the death of almost three thousand people. Fifteen of these were alumni of Binghamton University. This was a desperately sad time for our campus; all of us mourned our lost students. I felt deeply saddened by the loss of Paul J. Battaglia, a member of the class of 2000 who was at work on the one hundredth floor of one of the World Trade Center towers at the time of the attack. Paul, one of our most talented student leaders, had won the Student Leader of the Year award for his outstanding work at WHRW, the campus radio station, shortly before he graduated. As an award presenter, I had watched him walk across the stage, smiling with delight: a brilliant, extremely promising student. Paul had gotten an excellent job in the New York City financial world; then, all of a sudden, he was gone. His family, friends and fellow students at WHRW missed him terribly.

Two difficult times—the turbulent sixties/seventies and the terrorist attack of 2001—come together in a Moe Loogham story told by a WHRW program director in April 2005:

> *Moe is the spirit of WHRW. He lived in the old station before we moved, and then he came here. We think he's from Long Island originally. He protects the station from the FCC and from rogue DJs who curse on the air and steal CDs. He also donates music sometimes. Of course, it's just*

people who write Moe's name on their vinyl covers, but you know. They wouldn't do it unless Moe inspired them.

You can tell Moe's around when you're all alone at the station and you feel someone else there. Whatever you do, don't freak out. Relax and say hi. He's very friendly, and as far as we can tell he only wants us to succeed. He also plays matchmaker quite a bit.

Since Paul died on September 11, some station members think he's been looking out for us too. That's why you see his name in the "Peace, love, Moe" mantra: "Peace, love, Moe and Paul."

This touching but humorous story portrays Moe as a kind protector of student radio station members. The story's teller, who asked to remain anonymous, explains, "We think [Moe is] from Long Island originally." This helps students identify with the legendary character, since many Binghamton students come from the New York City area. Moe cheers students up and adds a little excitement to their lives. When the radio station moved to new quarters in the renovated University Union, Moe came too. It is comforting to see that Paul Battaglia, who loved WHRW and did so much to contribute to its development, has joined Moe as a representation of the station's spirit. If you turn your FM radio's dial to 90.5, you may hear a current station member sign off with the traditional blessing "Peace, love, Moe and Paul." You will certainly hear some good music, too.

CHAPTER 6
ROADSIDE GHOSTS

One of the Southern Tier's most intriguing legends is "The White Lady," connected to a notoriously dangerous curve on Route 17 near Owego. This local legend cycle follows the pattern of the internationally famous "Vanishing Hitchhiker" and suggests that people recall the murder of a young woman in the early nineteenth century. A genuine murder mystery awaits solution by researchers and legend-tellers. Mysterious stories of roadside ghosts scare and perplex young listeners, reminding them to take care when they drive at night.

A little more than four miles from Owego stands a mountain cliff called Devil's Elbow, Devil's Curve or Devil's Bend. While passing this local landmark, drivers have had strange experiences. Legends about these experiences vary, but all describe a young woman who died an untimely death in an accident. In most versions she appears by the side of the road, trying to get drivers' attention, but in some she appears inside the car. Sometimes she makes drivers think they have run over her, giving them a terrible fright. In the last part of the story, the young woman vanishes from the car or the roadside. Before vanishing, she may ask the driver to stop at the bottom of Devil's Elbow Hill. When the driver goes to the door of the nearest house to ask about the young woman, he learns that she died in an accident on Devil's Elbow Hill many years ago. In some versions he sees her in a picture, wearing a beautiful white dress.

As Jan Harold Brunvand explains in *The Vanishing Hitchhiker*, legends about roadside ghosts have a long, distinguished lineage. One of the

earliest vanishing hitchhikers appears in the book of Acts in the Bible. Closer to the form of more recent legends are early European legends about saints traveling down country roads. In the United States and other parts of the world, vanishing hitchhiker legends became popular around the turn of the twentieth century, when cars began to take the place of horses and carriages. The most common pattern of twentieth- and early twenty-first-century legends of this kind involves proof that the driver has really seen a ghost: a portrait, a sweater, a scarf, a wet spot or something else.[52] The last chapter of Louis C. Jones's *Things That Go Bump in the Night* offers a summary of New York hitchhiker legends, including stories about Devil's Elbow.[53] An important addition to his study is Lydia M. Fish's article "Jesus on the Thruway," which documents legends about a "Jesus hitchhiker" traveling through western New York. This hitchhiker, dressed in a seamless white garment, tells the driver to prepare for the Second Coming. He delivers a serious message for everyone in the world, not just the driver of the car in which he has chosen to hitchhike.[54]

I came to Binghamton University shortly after Fish's article on the "Jesus hitchhiker" was published and thought I might learn more about him from my students, but that did not happen. Very few of my first students came from western New York. Most of them hailed from New York City and Long Island, but some had grown up in Binghamton, Owego and other nearby towns. Many of the "townies" had heard about the woman in white who haunted Devil's Elbow. Elena, a young woman of Czechoslovakian descent, told me about our famous local ghost in 1977:

This is supposed to be true. One night, years ago, out on a bad curve in the road near Owego—it's called Devil's Elbow—there was a bad car accident. A couple was on their way to the prom, and the girl ended up getting killed in the crash. They say that sometimes at night, people driving on that curve report seeing a girl walking along the road in a white prom gown. A friend of mine claims that he saw her one night when he was driving out there, but he didn't stop because he was too afraid. I don't know if he was telling the truth or not, because he was a little drunk, but I've heard of other people who have seen her.

What does Elena's story tell us about Devil's Elbow? First, it shows that young people worry about this notorious curve and wonder if they'll see a ghost there; the legend warns them to be careful. Second, the story emphasizes the girl's prom gown, so it has particular meaning for teenagers

on the way to a big dance. The young accident victim in the story who dies is not always on her way to a party, but she always dies tragically, giving other young people a sad and educational *memento mori*.

Since the White Lady of Devil's Elbow wears a white dress, we should consider the meaning of the color white. In European tradition, white means innocence, purity and virtue; it can also represent death. In ancient Egypt, white was the color of death, while black was the color of life. White also has a connection to death in Asian cultures. Among the various White Lady legends around the world, some of the best known are British ghosts that foretell a death or remind people of traumas that they have suffered. The White Lady of Willow Park in Newton-le-Willows, for example, was murdered by her husband on her wedding night. Each White Lady warns young women to try to avoid a tragic, untimely death.

One of my first student collectors of local folklore was Linda, a Binghamton resident who gathered legends from her grandmother and other relatives. Her grandmother, who was born in a small Southern Tier village early in the twentieth century, told this version of "The White Lady" in 1979:

> *Many, many years ago, a young girl was walking down the road near Devil's Bend. This was before there were many cars. She lived on the road and liked to go walking by herself. Even though it was getting dark, she kept walking down the road. Just as she got to the curve, a wagon came rumbling around from the other side. Something spooked the horses, and they ran wild. It's her ghost that now walks the road there and that people see. If you pick her up, she disappears before the car stops. And she leaves her white scarf and calling card on the seat. If you go up to the house they say you see her picture hanging inside the living room, and the people there tell you she used to live there and explain what happened to her.*

This story definitely follows the pattern of the classic American "Vanishing Hitchhiker" legend, including a generous amount of proof that a ghost has entered the car: both a white scarf and a calling card, as well as a picture hanging in the living room. Linda's grandmother does not specify exactly how the girl died, but we assume that the horses that "ran wild" mortally wounded her. There is, of course, a lesson to be learned: girls who go out walking by themselves at dusk may get into terrible trouble. Tokens of the ghost's presence—her scarf and her calling card— serve as reminders that young women should not go out by themselves and

A white dress hovers near a horse-drawn carriage. *Courtesy of the Tioga County Historical Society. Photograph by Geoffrey Gould.*

throw caution to the winds. These two white objects identify their bearer as a proper young lady of the Victorian era. The horses that run wild represent dangerous deviation from safe and proper behavior, while the white scarf and calling card symbolize the innocent demeanor that young ladies should follow.

Calling cards remind us of late nineteenth- and early twentieth-century etiquette in the eastern United States. Parents taught their children to follow the right protocol for visiting friends; young ladies of upper- and upper-middle-class families went on outings with chaperones. These days, young people's social networks depend more on Facebook than on small pieces of paper imprinted with names. The "White Lady" legend told in 1979 contrasts social safety with danger, showing that too much independence can lead to tragedy.

The most popular twentieth-century versions of "The White Lady" in the Southern Tier describe an unexpected meeting with a young woman wearing a white prom gown or wedding dress. Some of the best renditions of the legend come from people's personal experience. Here is a story that Dave, the father of my student Irene, told in 2004:

> *It was misty and foggy, might be raining a little bit, dark. Dad was driving and Mom was in the front seat. I think Lynda was between them. I always rode behind Dad, or tried to. We always fought over who got to sit where. We were going east to west over Devil's Elbow Hill. Saw a flash of white in the passenger side headlight. I said, "Dad! You just hit her!" Mom and Dad turned around and said, "Who?" "The lady in the white dress!" Mom said, "Oh, there wasn't anybody!" We drove right through her. Never saw her again. It wasn't until many years later that I heard the stories.*

Did the car actually hit this ghost? Dave thinks it did, but his parents and sister do not notice anything unusual. The sentence "We drove right through her" sends a shiver up the listener's spine, suggesting that the ghost was really there. Further authentication comes from the fact that Dave had never heard "White Lady" legends; he did not learn any of them until many years later.

Irene, Dave's daughter, fills in the legend's details:

> *A long time ago, on a dark and stormy night, a newlywed couple was driving over Devil's Elbow Hill Road. It was so foggy that they never*

saw the headlights of the oncoming truck—the groom's body flew out of the car on impact. The body was never found. The bride, however, was crushed in the car. She died instantly. Sometimes, on a dark and stormy night, if the fog is just thick enough, you will see the bride standing in the road waiting for her groom to join her. Just for reference, Devil's Elbow is called that for a specific reason. The road goes almost vertically up to a point and down again very steeply. The road isn't in use anymore, but the story is still told and some have even been said to see a white figure standing on the old abandoned road. Devil's Elbow Hill is located on the way to Waverly, New York, if you're taking old 17.

Irene's story creates a wonderfully spooky atmosphere, suggesting that any of us might see the White Lady "on a dark and stormy night, if the fog is just thick enough." Here the White Lady is a bride who patiently awaits her groom. Like Miss Havisham, the grim spinster of Charles Dickens's *Great Expectations*, she will always await her groom but never find him.[55]

I learned another story about the White Lady from Isabelle, a twenty-one-year-old student, in 2004. Isabelle described a frightening encounter that her aunt and cousin experienced while driving at night:

My aunt was driving home with her daughter. My cousin was sitting in the back seat, and while driving, my aunt heard a bump, like she ran over something. So she got out of the car to see if she ran over anything. She didn't find anything. So she went back into the car and looked into the backseat to check if her daughter was okay. But when she looked in the backseat, she saw a white lady sitting next to her daughter. She was scared out of her mind, but the white lady wasn't there when she looked again.

This story seems scarier than some of the other White Lady variants, because the driver of the car does not see a ghost at first; she just feels a bump and stops to check what happened. Then she sees that a white lady has materialized in the back seat of her car, next to her daughter. Does the lady want to help or harm the girl? We do not know, since she vanishes very quickly. In any case, her appearance next to the girl fits the pattern of advising or warning that this legend cycle follows.

While the legend of the White Lady of Devil's Elbow is one of many "Vanishing Hitchhiker" stories around the United States, it has an intriguing connection to an actual murder. Gerald R. Smith, Broome County's historian, shared this account with my student Sarah in 1998:

One famous local story is the "Lady in White" that appears in the area of Route 17C, by Owego/Tioga County. People who pass by say they've seen a figure that quickly appears and disappears, a young girl wearing a long white dress. Sightings of her date back to the early 1900s, and in 1932, the skull of a young girl was uncovered in that area. The coroner who examined it found it to be a woman in her early twenties, and the skull had marks on it that suggested that she was murdered by a blunt object, probably the flat side of an axe or some other object. The skull had been in the ground there for about a hundred years. At the time of her death, the area was next to a tavern that had a rough clientele that was famous for many serious fights between customers, some even ending in death.

Like me, Smith had heard local residents talk about encounters with the White Lady, and he wondered whether the young woman's murder around 1832 could explain the legend's origin. Has this violent death almost two hundred years ago remained in local people's memory as a legend? A look at a study of somewhat similar New York State legends shows how this sort of memory can persist from the eighteenth century to the present.

View of the Susquehanna River and Route 17 in Owego.

Judith Richardson's *Possessions: The History and Uses of Haunting in the Hudson Valley* (2003) finds that ghostly women in black, gray and white tend to comment on the history and nature of their communities. One intriguing ghost has stayed in the public eye: "the ghost of a female being dragged behind a ghostly horse, reported variously near Spook Rock and Spooky Hollow on the outskirts of what is now the village of Leeds."[56] Over time, legends have described this ghost as white, black, Scottish, German, Spanish and Indian. Her story originated from the eighteenth-century murder of Anna Dorothea Swarts, a servant who worked in the house of a rich man named William Salisbury. A document composed in 1762 explains that Salisbury "did beat and force and Compell the said horse So Swiftly to Run that the Horse aforesaid the aforesaid Anna Dorothea Swarts then and there Instantly died."[57]

Was Anna Dorothea Swarts a slave or an indentured servant? Did Salisbury kill her in this cruel way because she rebelled, broke rules or resisted romantic advances? Richardson explains that the indictment was dismissed, possibly because the court found Salisbury to have acted within his rights as a master. Although the court did not hold Salisbury responsible, ghost stories kept this gruesome murder on people's minds. In 1824, the editor of a New York City newspaper told the story of a gigantic white horse "dragging a female behind, with tattered garment and streaming hair, screaming for help."[58] Later the ghost takes other forms. Richardson makes the point that "the ghost is both vestige and novelty, positive and negative, powerful and powerless, a possessing force that descends upon the town and through history, and something passive that is possessed."[59] Although we will never know exactly what happened to the young servant or slave from Leeds, we know that this ghost refuses to be silenced. In various political and social contexts, she has made her presence known for almost 250 years.

Like the ghost of Anna Dorothea Swarts, the White Lady of Devil's Elbow has a connection to a long-ago tragedy. Thomas C. McEnteer, editor of *Seasons of Change: An Updated History of Tioga County, New York* (1990), documents the history of Devil's Elbow that influenced White Lady legends. His chronicle of changes between the 1830s and 1990 helps us understand how White Lady legends grew and became locally famous.

One of the most interesting parts of McEnteer's chronicle is his description of the 1932 discovery of a woman's skull by a steam shovel operator at the bottom of Devil's Elbow hill, near the railroad viaduct of Route 17C. The coroner, Dr. K.F. Rubert, determined that the skull "was

of a woman in her early twenties, slender of build, weighing about 120 pounds." Speculating that she had been murdered with "the flat side of a board or an axe," he deduced that her bones had lain in the ground "for nearly a century."[60] McEnteer notes that the skull was found near the site of the old Broadhead Tavern, which opened in the early 1800s. Customers who visited the tavern included "hardened and rough characters, who drank freely and were known to cause many serious and sometimes fatal injuries to other patrons."[61] In 1925, the builder of the Devil's Elbow Rest Stop for motorists on the Liberty Highway bought some of the remains of the Broadhead Tavern to use in building a restaurant.

Can the young woman killed near the Broadhead Tavern be the original White Lady? McEnteer asks whether she wants to haunt her murderer. He does not answer that question himself, leaving the answer to those who hear the stories. Besides describing the discovery of the skull and the construction of the new restaurant from the tavern's old materials, he explains that stories about a White Lady who "appeared and disappeared" began to circulate around 1925—the same year that the Devil's Elbow Rest Stop opened. It is not surprising to hear that some of the first motorists who stopped at the rest stop enjoyed hearing and telling stories about encounters with this elusive female ghost. Children and adolescents also enjoyed hearing about her and playing pranks related to the legends. In 1951, Endicott pranksters dressed a young woman up in a long white dress, to which they attached the kind of reflective tape used on road signs. Police caught the pranksters and made them stop.[62]

Since the mid-twentieth century, there has been an upsurge of interest in the legend's nineteenth-century origins. Gae E. Crosby and Keith E. Greene co-authored a story titled "Lady in White…Tioga County's Ghost of Devil's Elbow" in 2007. In this story, a young Owego resident named John suddenly sees a young woman in white hitchhiking by the side of Devil's Elbow; she is "soaked from head to toe from the hard cold rain and she [is] carrying a bouquet of white flowers."[63] He brakes, lets her into the car and then stops at the bottom of the hill when she asks to get out. The next morning, John's father tells him that the remains of a young woman had been found near the Broad Head Tavern: "Law enforcement always speculated that the young gal ran into an undesirable from Broad Head Tavern on her way home but couldn't prove it." Shaking as he considers what his father told him, John gets into his car, drops his keychain and picks it up. At this moment he finds proof that the ghost really sat in his car: "There was the keychain…amongst white floral petals."[64]

This charming story brings us back full circle to early twentieth-century White Lady legends, which emphasize such Victorian details as scarves, calling cards and floral bouquets. All of these tokens of the ghost's presence are, of course, white, highlighting her innocence and guilelessness. Emphasis on an "undesirable" from the tavern killing the girl fits the historical details that McEnteer includes in his chronicle of Tioga County's development. This character also fits the contemporary legend's warning against young women going out alone without protection from others. Among Owego residents, does the memory of rough tavern visitors solve the mystery of the young woman's murder in the 1830s? That might seem to be the case, but more of the story needs to be told.

When I spoke with Theresa Wells, a staff member of the Tioga County Historical Society, I learned that Owego residents were explaining a motive for the young woman's murder: the theft of a cow. I visited the Historical Society in the winter of 2011 and asked one of the volunteers, Alfred, if he knew the story about the cow. Having lived in the Owego area for many years, he knew the story well and kindly shared it: "A young couple with a cow stopped at an inn. The next day the owner of the inn had the cow, but the young couple was gone. Some time later people found the body of the young man. Then in 1932, workers found the skull of the young woman. That was how they knew what happened."

Alfred's concise, interesting story offers a different frame of reference from that of many White Lady legends. Rather than being alone, this murder victim has a husband, and both of them own a cow. Their murderer is not a shiftless transient but a greedy innkeeper who wants to get new livestock without paying for it. When oral history collides with an appealing legend cycle such as the "Vanishing Hitchhiker," the resultant stories reflect both sources. Owego's oral tradition has retained concern about an innocent young woman's death while emphasizing exciting aspects of her reappearance that entertain listeners. That is the essence of a great local legend: both connection to an important landmark and delight at a sudden glimpse of the unknown.

Rod Serling, whose boyhood experiences in the Southern Tier had much to do with his success in creating *The Twilight Zone*, was probably familiar with the White Lady of Devil's Elbow. One of the show's most chilling episodes is "The Hitchhiker," in which a young woman named Nan Adams attempts to drive from New York to California. Nan, a character named after Serling's daughter, gets help from a mechanic in Pennsylvania after her car has a flat tire. When she gets back on the road, a sinister-looking

male hitchhiker appears by the side of the road. The hitchhiker appears over and over. Rattled by these repeated appearances, Nan panics when her car stalls on railroad tracks and almost gets hit by a train. Finally, she calls her mother. A woman who answers the phone explains that Mrs. Adams had a nervous breakdown after her daughter died in a car accident in Pennsylvania. One last time, the hitchhiker appears, saying, "I believe you're going my way." This hitchhiker is, of course, the Grim Reaper. Serling concludes with these lines: "Nan Adams, age twenty-seven. She was driving to California, to Los Angeles. She didn't make it. There was a detour through the Twilight Zone."[65] Remembering Rod Serling, we can view Tioga County's White Lady legends as narratives from a shadowy area between the past and the present where we can find deep meaning.

CHAPTER 7
SPECTRAL PATIENTS

D uring the nineteenth century, patients traveled by train to Binghamton to seek cures for cancer and other serious diseases. Gradually, the Southern Tier became a famous destination for patients with both physical and mental ailments. Ghost stories suggest that some of those patients still haunt the Southern Tier, letting the living know about their troubling maladies and stressful treatments. Reenacting scenes from their difficult lives, they show us an important part of the Southern Tier's history.

Not all stories about past healthcare include ghosts. Some of these narratives help us understand the spirit of entrepreneurship that launched new medicines and healthcare regimes in the nineteenth century. This zeal for creating popular medicines resulted in products that people still use today. If, like me, you want to taste some of the Southern Tier's historic Swamp Root, you can easily do so.

SWAMP ROOT AND OTHER CURES
(BINGHAMTON AREA)

One of the folk heroes of Southern Tier health care is Dr. S. Andral Kilmer (1840–1924), who invented Swamp Root. This tasty remedy quickly became a popular cure for kidney, liver and bladder problems. Its ingredients included African buchu leaves, Colombo root, swamp

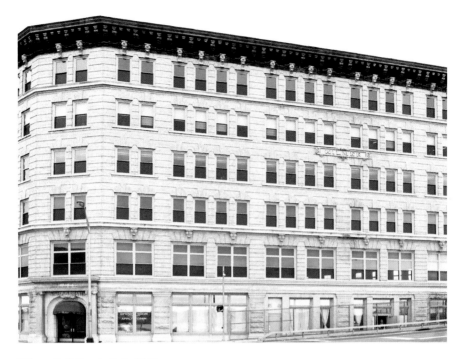

Kilmer Building, built in 1903.

sassafras, skullcap leaves, Venice turpentine, valerian root, rhubarb root, mandrake root, peppermint, aloes, cinnamon, sugar, and alcohol, according to "The Kilmers of Binghamton, New York" by John Golley, a descendant of the Kilmer family. Although alcohol only accounted for 10 percent of the mixture, it enhanced the remedy's popularity. In 1881, Dr. Kilmer gave his brother Jonas control of their patent medicine company. Jonas Kilmer's son Willis (1869–1940) became the main promoter of Swamp Root and other medicines, and in 1903, the six-story Kilmer Building went up in downtown Binghamton. The Pure Food and Drug Act of 1906 created difficulties for the Kilmer Company, but Swamp Root stayed on the market, and people can still buy it today.

On my bookshelf at home stand two pale blue Swamp Root bottles. Raised letters on the bottles identify them as bearers of "Doctor Kilmer's Swamp Root Kidney, Liver and Bladder Cure." For years I have enjoyed gazing at these bottles, but I had never tasted Swamp Root before starting the research for this book. Wanting to taste the Kilmers' famous cure, I called the Shangri La gift shop in Ithaca and ordered a small bottle. The

young man who took my order mentioned that he had received unsolicited testimonials from Swamp Root seekers living in the United State and abroad. Some of them praised Swamp Root's effectiveness in curing kidney, liver and bladder ailments; others claimed that it eliminated skin problems.

A few days after I placed my order, a friend of the proprietor at Shangri La brought a bottle of Swamp Root right to my door. How often do stores send deliveries directly to our homes? In the twenty-first century, that does not happen very often. When I took my first sip of Swamp Root, I found that it had a sweet, spicy flavor. Its taste drew me back to the nineteenth century, when people throughout the United States took a hearty swig of Swamp Root every day. As recently as the winter of 2009, when the Kilmer Brasserie in the old Kilmer Building closed, customers enjoyed Swamp Root cocktails made with this very same substance. Slowly, I savored the aromatic patent medicine that had promised to cure so many ills. Flavor-rich and mysterious, it offers more pleasure to the taste buds than most medicines distributed by doctors do today.

Swamp Root has given Dr. Kilmer enduring fame, but he also deserves to be remembered for his other bold ventures, including the invention of a mysterious cure for cancer. In Osborne Hollow, which he renamed Sanitaria Springs, Dr. Kilmer built his sanitarium and hydrotherapium in 1892. Besides the main sulpho-phosphate spring, the hydrotherapium offered baths called Blue Lithia, Black Magnetic, Red Iron and Ferro-Manganese, Golley reports. Cancer patients traveled to Sanitaria Springs and to Dr. Kilmer's Cancertorium at 254 Conklin Avenue in Binghamton; if they agreed to undergo treatment for at least three months, Dr. Kilmer would cover their train fare. According to Golley, Dr. Kilmer's homeopathic cancer cure "would cause the cancer to be expelled from the body; [it] would literally fall off." Golley's grandmother and great-aunt claimed that they had seen dramatic cancer cures take place.[66] Did Dr. Kilmer actually invent a medicine that cured cancer? Since we have no formula for his cancer cure, we will never know.

Dr. Kilmer's nephew, Willis Sharpe Kilmer (1869–1940), made Swamp Root, Ocean Weed Heart Remedy and other cures some of the best-known products in the United States. Besides energetically marketing his products, Kilmer founded the *Binghamton Press* and built Binghamton's first golf course. He also built a racetrack next to his family's mansion on Riverside Drive. The most famous Kilmer horse was Exterminator, who won the Kentucky Derby in 1918. In this way, the Southern Tier developed a connection to the Deep South.

INEBRIATE ASYLUM (BINGHAMTON)

In contrast to Dr. Andral Kilmer, who mixed herbs with alcohol, Dr. Joseph Edward Turner established an imposing facility for the treatment of alcoholics. Having visited treatment facilities for alcoholics—then known as inebriates—in Europe, Dr. Turner wanted to follow a similar approach in New York State. He had trouble getting support from the New York legislature because people did not commonly view alcoholism as a disease in nineteenth-century America. After lively discussion, the charter for the United States Inebriate Asylum for the Reform of Poor and Destitute Inebriates gained approval in 1854; the name became New York State Inebriate Asylum in 1857. Binghamton's distinguished architect Isaac Perry drew up plans for the castellated Tudor buildings that people would call "the castle on the hill"; the buildings' construction began on a 250-acre lot in 1858.

Fires and disputes marred the Inebriate Asylum's early years. Two fires took place in 1863, and another fire caused much damage in 1864. Dr. Albert Day, who took Dr. Turner's place as director of the asylum, was accused of setting a fire that suddenly started in 1870, according to John Crowley and William White's *Drunkard's Refuge: The Lessons of the New York State Inebriate Asylum* (2004).[67] In 1872, the number of patients at the asylum rose to 334, but in 1879 very few patients remained. In 1879, the institution's name changed to Binghamton Asylum for the Chronic Insane; one year later, the name changed again to Binghamton State Hospital. By the mid-twentieth century, the hospital had a reputation for innovative therapies. Electric shock treatments began in the early 1940s, and prefrontal lobotomies followed in 1946. Drug therapy started in the mid-1950s. In 1974, the hospital's administrators introduced another new name: Binghamton Psychiatric Center. Current signs bear the name Greater Binghamton Health Center.

Now under renovation as a new campus for SUNY Upstate Medical University, the castle on the hill has developed a reputation as a haunted place. Young people have wandered around the buildings and grounds, seeking evidence of ghosts. Since such visits may interfere with patients' privacy and care, I do not recommend going to the hospital grounds. I do, however, believe we should listen to stories about spectral patients who roam the campus, enacting troubles that they experienced during their lifetimes.

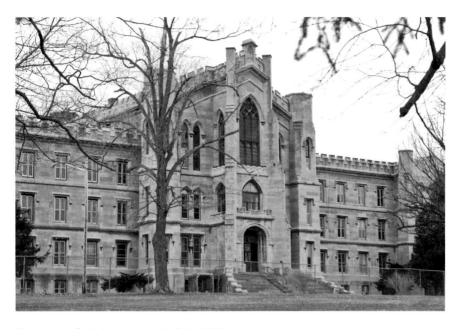

Binghamton Inebriate Asylum, built in 1858.

Scholars have studied the day-to-day lives of patients in state psychiatric hospitals. Mental healthcare administrator Darby Penney and psychiatrist Peter Stastny published *The Lives They Left Behind: Suitcases from a State Hospital Attic* in 2009. Their study of ten patients at Willard State Hospital, which closed in 1995, offers insight into New York state hospital residents' struggles. Ghost stories about spectral patients provide a different view of the past, dramatizing the sadness and death of those who could not get away from their institutions.

One of my former students, Chelsea, recently told me about late-night visits to the Binghamton Psychiatric Center with her high school friends:

> *We used to go to the old Psych Center buildings. If you go to the last building on the unpaved road within the complex, there's a building with chicken wire fences on all the balconies going up four floors. That's fact, here's legend: that's where the women's dorms were back in the '50s. The women were not treated like humans and they were subjected to the most extreme torture on the third floor. If you go there at night (maybe when there's a full moon), you can see their silhouettes shaking the chicken wire fence trying to escape from the balcony. One woman broke through the*

fence, and you can sometimes hear her scream as she falls to her death over and over again in the afterlife.

What a chilling story! Silhouettes of female patients shaking their building's chicken wire fence as they desperately try to escape could frighten anyone, especially late at night under the pale illumination of a full moon. The suggestion that the women "were subjected to the most extreme torture" brings to mind nightmarish images of suffering. Most upsetting of all is the scream of the woman who breaks through the fence and falls to her death repeatedly. The idea that spirits must repeat their past actions is an old one. In Greek mythology, King Sisyphus suffers the punishment of pushing a heavy rock up a hill throughout eternity. For these spectral patients, though, reenactment of attempted escape and death does not seem to be a punishment. Instead, reenactment shows visitors that they should pay attention to the history of psychiatric hospitals in which patients endured difficult times.

I learned another story about a ghost appearing on an outside staircase at the Binghamton Psychiatric Center from my student Briana, who had interviewed a nurse who used to work at the center. The nurse's story, told in 2010, follows:

> *There has only been one time that I have had a weird encounter that I haven't been able to explain. After work one night, it was about 10:00 p.m. and I was trying to make my way out of campus. I was new there, so I got confused on the roads and ended up going down the dead end road. The buildings just seemed so interesting because they were so old. I slowly drove by, looking up the hill at the building with the tall white pillars. To the right of the building is the outside staircase that is encased with fencing, you know? Well, as I was looking just to the side of it, something flashed across as if someone was walking down those stairs. I put the car in park and waited to see if I could see anyone. I waited for over a minute, then got too scared and had to go home.*

Less scary than the previous story, this one describes a flashing light on a fenced-in outside staircase. Does this light come from a ghost walking downstairs? The narrator does not know, but she certainly feels scared. Traditionally, lights in cemeteries and other places show that a ghost wants to make itself known to living visitors. Twenty-first-century ghost hunters often look for orbs, bright circles of light that appear on a photograph's

Exterior staircase of an unused building at the Greater Binghamton Health Center.

surface; some photographs taken on the Psychiatric Center's campus have had orb-like spots. While some people want to learn more about ghostly lights, others want to get away from such scary phenomena as soon as they can—and who can blame them?

Besides lights and other visual phenomena, sounds suggest a ghost's presence. An employee of the Binghamton Psychiatric Center shared this story with Briana, Jess, Katie and the other students who worked together:

> *An old cop that used to work here said that he was in that building right there behind you doing a basic inspection. He was on the second floor when he heard something that sounded like a six-hundred-pound safe crashing to the floor above him. He ran up there immediately found nothing that had so much as moved since the last time he went up there. He couldn't find anything that would explain that noise.*

This story's narrator knows the security guard who heard a heavy object crash to the ground, so he uses the "friend of a friend" format that characterizes the legend. A security guard would usually excel at inspections, finding a reason—if there is one—for a loud, startling noise.

Since he finds no rational explanation, we can speculate that the sound came from a ghost. Could it be the ghost of a patient that wants attention? We do not know, but the story makes us wonder.

RESCUE MISSION (BINGHAMTON)

Besides hospitals, care-giving institutions for people under temporary or long-term duress have inspired ghost stories. One of the first such institutions in the Southern Tier was the Rescue Mission at 128 Washington Street in Binghamton, built in 1855. Staffed by caring individuals who wanted to help people make a transition to independent life, the Rescue Mission offered hope and comfort.

In 2004, my student Robin collected some intriguing stories about a ghost that haunted the old Rescue Mission, which had been remodeled to provide space for the Art Mission and several apartments. Apartment residents and the proprietor of the Art Mission were having trouble with their telephone service. A strange voice on the telephone line suggested the presence of a female ghost that wanted to communicate with the living. Robin collected the following story from Dave, an artist in his thirties who lived in one of the apartments:

> *On a Sunday early in March I awoke to discover my phone line was entirely dead. The light on the dial pad of the phone didn't even light up. I ended up e-mailing my father because I was supposed to call him that morning. He suggested that it might be my phone that had the problem.*
>
> *I had another phone that I didn't like but could at least use to test the problem. The phone jack was behind my desk and difficult to get to, but in spite of this I reached all the way back to unplug the old line and plug in my other phone. It was a wasted effort, because the line was still dead. I took the phone off the end of the phone cord so I wouldn't have to reach behind the desk again.*
>
> *I contacted Verizon the next day, and they sent a technician out. He went to the easy-to-reach phone jack and plugged my spare phone into that, and there was a dial tone. I picked up my desk phone, and there was dial tone there as well. He heard it too. He thought perhaps*

someone was doing work on the lines and had interrupted my service the day before.

That night I got a phone call and answered it. It was an old woman's voice, and I couldn't make out her words well. She was looking for someone, and she couldn't hear me well either. The line was full of noise. I explained that I couldn't hear her and hung up the phone. When I hung up the phone, I saw that I had unplugged the phone the night before but never connected it to the phone cord. The plastic modular end was sitting on the floor right in front of me, where I'd left it when I was testing the other phone the day before.

Dave's story begins with a long description similar to that which any of us with telephone trouble might share with a friend. Phones that do not work cause great frustration, especially in this era when we expect technology to do its job swiftly and well. In a sudden shift from the familiar to the paranormal, Dave discovers that an old woman's voice has come to him through an unplugged phone. Seeming to come from the past, the woman's voice suggests that deceased residents or staff members of the Rescue Mission want to keep in touch with folks who live there now.

Traditional ghostlore includes stories about spirits' voices that come through unplugged or broken telephones, as in Stephen Wagner's "Phantom Phone Calls."[68] In the case of the Rescue Mission ghost, a mysterious voice seems hard to understand. Robin's account of what happened mentions that after she moved into the apartment previously occupied by Dave, she heard on her phone "an older woman's voice speaking in an awkward manner, almost like 'baby-talk,' very slowly trying to pronounce my name." She and other apartment residents in the building wondered if the woman might have been "an older woman, perhaps a seamstress or a cleaning woman, or even a sister of charity"; she "[seemed] gentle and might be watching over the inhabitants of the building as she might once have watched over its other inhabitants in life." This gentle ghost might also be a patient from the mid-nineteenth century, when some early Binghamton residents struggled with indigence and alcoholism.

Robin's suppositions about the Rescue Mission ghost come from more than unusual telephone conversations; they also come from visual images. When she interviewed Dave, he told her, "One time in particular I woke up to see a person standing in the doorway looking at me in bed. I looked harder, and then it was as if my eyes focused right past her and she was not there at all." His girlfriend also saw a female figure in the bedroom;

this figure made her feel so sad that she kept the bedroom door closed. And Robin herself watched with fascination as the bedroom door of the apartment where Dave and his girlfriend once lived "slowly swung open in a jerking manner, as if someone gave it a little shove, then another, and then another, until it was fully open." It seemed that a watchful, active ghost was determined to remain part of the former Rescue Mission's daily routines.

"YOU'RE GOING TO BE ALL RIGHT" (CORNING AND VESTAL)

Some ghost stories teach us about the lives of people who died long ago, but others help us handle deaths that occurred in the recent past. Coming to terms with the loss of a family member or friend can take a long time. There may be a particular need for comfort if the lost loved one is a child or an adolescent. After an untimely, unexpected loss, it can be hard to accept what happened. Family members and friends may find some measure of consolation in stories that suggest the child's spirit is still present. While these stories vary, they tend to conclude with a consoling message.

During the past thirty years, I have heard a number of ghost stories about young people who died of cancer in the Southern Tier, where Dr. Kilmer once owned his Cancertorium. In many of these stories, the dead child's spirit assures someone else that all will be well. Sometimes this message focuses on the well-being of the person who listens; other times it emphasizes that the child him- or herself is doing well after death. Also characteristic of these stories is revelation of details identifying the spirit as the child who passed away.

My student Heather collected a story about a teenager's ghost from a young male resident of Corning in 2010:

When Mama O'Connor bought the house she lives in now, she found out a family had lived in it a while back, and the son had died of cancer when he was like sixteen. When she moved in there was even a baseball picture of him the year before he died up on the wall. So a week later she wakes up in the middle of the night, she knows she's awake, and

she turns around and there sitting on the side of the bed is a sixteen-year-old boy in a baseball uniform looking at her who says, "You're going to be all right."

In this intriguing story, a teenage boy's spirit stays in the house where he passed away. As in other stories of haunted houses, the boy's spirit seems attached to his family's home. It seems strange that the boy's family left his picture on the wall when they left, but the picture helps the mother confirm the identity of her ghostly visitor. Some "Vanishing Hitchhiker" legends also reveal the identity of a ghost through the presence of a portrait. Without a visual image, it would be hard to figure out who the boy is.

Why does the boy's ghost tell Mama O'Connor, "You're going to be all right"? He seems to feel a connection to her, almost as if she were his own mother. Perhaps he senses her sadness about his early death and wants to assure her that her own life will go well, or perhaps he just wants to share his understanding of the future. Sitting on the bed, looking at the new mother who lives in his house, he gives her a consoling message. The story acknowledges Mama O'Connor as a sensitive person who knows how to communicate with a teenage boy's spirit.

Another story came from Amelia, a young resident of the town of Vestal, in 2004. Like the story about the teenage baseball player, it offers a clue to confirm the ghost's identity, but in this case the clue comes from a dream:

My friend Mandy's sister had a bad case of cancer, and one night I had a dream about her. She told me, "I have to go now, but let my parents and sister know I'm okay, and I'll be all right, and I'm going to a better place, and also tell my sister that I'm with Johnny." I woke up from the dream and wrote my friend an e-mail to tell her what my dream was about. The next day at school, one of my friends said to me, "Did you hear what happened last night? Mandy's sister passed away." I was surprised, because I didn't know she was in the hospital. When I went to the wake, her parents said how glad they were that I let them know their daughter's okay, and later I found out that Johnny was an inside joke between her and her sister.

When Amelia learns that the name Johnny was an inside joke between Mandy and her sister, she realizes that the sister's ghost wanted her family to

know she sent the message. Why doesn't the ghost bring the message directly to her parents or sister? Perhaps the ghost thinks that such a confrontation after a painful loss would be too hard for her family to take. Through an e-mail from her trusted friend, Mandy learns that her sister is all right. Both she and her parents feel better after receiving these words, which confirm their hope for life after death.

This hope for communication between the living and the dead helps explain why ghost stories are important to their tellers and listeners. Whether they describe haunted houses, churches, mansions, colleges, hospitals or roadways, ghost stories express a need to stay in touch with lost loved ones and to understand the past. Crossing the boundary between life and death, ghosts teach us significant lessons. The spirits that I have presented here are just a few of the many that appear in Southern Tier ghost stories. I hope other collectors will record stories of this kind, which provide insight into the Southern Tier's ever-changing history.

NOTES

INTRODUCTION

1. Jones, *Things That Go Bump*, 19.
2. Serling, "Walking Distance."
3. Norkunas, *Monuments*, 10.
4. Ainsworth, *Legends*, 38–39.
5. Richardson, *Possessions*, 11.
6. Temple, "Real American Heroes."

CHAPTER 1

7. Smith, *Valley of Opportunity*, 13.
8. Richter, *Ordeal of the Longhouse*, 280.
9. Jones, "From the Tuscarora Reservation," 134.
10. Ibid.
11. Ibid., 139.
12. Wallace, "Tuscaroras," 159–65.
13. Bowen, *One More Story*, xii.
14. Ibid., 3.
15. Ibid., 39.
16. Ibid., 40.

17. Ibid., 42.
18. Ibid., 52.
19. Winfield and Fisher, *Phantom Tour*.
20. Morgan, *League of the Iroquois*, 208–17.
21. Tucker, *Haunted Halls*, 156.
22. Bergland, *The National Uncanny*.
23. Gardner, *Folklore*, 86.
24. Ainsworth, *Legends*, 35.

CHAPTER 2

25. For further information about this concept, see Cross, *Burned-Over District*.
26. Smith, *Valley of Opportunity*, 22, 26.
27. Shakespeare, *Romeo and Juliet*.
28. Cadwallader, *Hydesville in History*.
29. Seekings, *Ladies of Lily Dale*, 4.
30. Wicker, *Lily Dale*, 22.
31. Ibid., 49.
32. Ibid., 50–52.
33. Gallagher, "Touched by the Spirit World," 1D.
34. Ibid., 7D.
35. Berardi, *Man at the Foot of the Bed*.

CHAPTER 3

36. Gordon, *Pauline*, 121.
37. Jones, *Things That Go Bump*, 114.
38. Ibid., 116.

CHAPTER 4

39. Kingman, "Owego," 58.
40. Ibid.
41. Hawthorne, *House of the Seven Gables*.
42. Jones, *Things That Go Bump*, 3.
43. Ellis, *Lucifer Ascending*, 163–71.

44. Thompson, *Motif-Index*.
45. Jordan, *I Knew This Day Would Come*, 3.

CHAPTER 5

46. Tucker, "Ghosts in Mirrors," 186–203.
47. Merton, *Seven Storey Mountain*, 304.
48. Frank, "Legends and Myths."
49. Tucker, *Haunted Halls*, 45, 204–7.
50. Frank, "Legends and Myths."
51. "Jimmy Igoe."

CHAPTER 6

52. Brunvand, *Vanishing Hitchhiker*, 24–40.
53. Jones, *Things That Go Bump*, 161–84.
54. Fish, "Jesus on the Thruway."
55. Dickens, *Great Expectations*.
56. Richardson, *Possessions*, 82.
57. Ibid., 84.
58. Ibid., 91.
59. Ibid., 123.
60. McEnteer, *Seasons of Change*, 750.
61. Ibid.
62. Ibid.
63. Crosby and Green, "Lady in White," 10.
64. Ibid., 13.
65. Serling, "The Hitchhiker."

CHAPTER 7

66. Golley, "The Kilmers."
67. Crowley and White, *Drunkard's Refuge*, x.
68. Wagner, "Phantom Phone Calls."

WORKS CITED

Ainsworth, Catherine Harris. *Legends of New York State.* Second edition. Buffalo, NY: Clyde Press, 1978.

Berardi, Josette. *The Man at the Foot of the Bed.* Frederick, MD: Publish America, 2011.

———. Personal interview. July 14, 2010.

Bergland, Renée L. *The National Uncanny: Indian Ghosts and American Subjects.* Hanover, NH: University Press of New England, 2000.

Bowen, DuWayne. *A Few More Stories: Contemporary Seneca Indian Tales of the Supernatural.* Greenfield Center, NY: Bowman Books, 2000.

———. *One More Story: Contemporary Seneca Tales of the Supernatural.* Greenfield Center, NY: Bowman Books, 1991.

Brunvand, Jan Harold. *The Vanishing Hitchhiker.* New York: Norton, 1981.

Cadwallader, Mary E. *Hydesville in History.* New York: Nabu Press, 2010.

Crosby, Gae E., and Keith E. Green. "Lady in White…Tioga County's Ghost of Devil's Elbow." *Tioga County Ghostly Tales.* Illustrated by Lindsey

Henninger. Owego, NY: Tioga County Historical Society and Museum, 2007.

Cross, Whitney R. *The Burned-Over District: The Social and Intellectual History of Enthusiastic Religion in Western New York, 1800–1850.* Ithaca, NY: Cornell University Press, 1950.

Crowley, John W., and William L. White. *Drunkard's Refuge: The Lessons of the New York State Inebriate Asylum.* Amherst: University of Massachusetts Press, 2004.

Daniels, Eve. E-mail communication. July 29, 2010.

Dickens, Charles. *Great Expectations.* New York: Penguin Classics, 2002 [1861].

Ellis, Bill. *Lucifer Ascending: The Occult in Folklore and Popular Culture.* Lexington: University Press of Kentucky, 2004.

Fish, Lydia M. "Jesus on the Thruway: The Vanishing Hitchhiker Strikes Again." *Indiana Folklore* 9 (1976): 5–13.

Frank, Dennis. "Legends and Myths of SBU." web.sbu.edu/friedsam/archives/studentpages/ghost. 2003.

Gallagher, Peg. "Touched by the Spirit World." *Press and Sun-Bulletin.* Binghamton, New York. April 18, 2010, 1D, 7D.

Gardner, Emelyn. *Folklore from the Schoharie Hills.* Chicago: Lakeside Press, 1977 [1937].

Golley, John E. "The Kilmers of Binghamton, New York." www.antiquebottles.com/kilmer.html. 1997.

Gordon, Hanford Lennox. *Pauline and Other Poems.* New York: G.P. Putnam's Sons, 1878.

Hawthorne, Nathaniel. *The House of the Seven Gables.* New York: W.W. Norton, 2005 [1851].

Irving, Washington. *The Sketch Book of Geoffrey Crayon, Gent. (1819–1820)*. Edited by Haskell Springer. Boston: Twayne, 1978.

"Jimmy Igoe—Fredonia's Eternal Student." www.facebook.com/group. php?gid=13903567351&ref=ts. 2011.

Jones, Elma. "From the Tuscarora Reservation." *New York Folklore Quarterly* 5, no. 2 (1949): 133–45.

Jones, Louis C. *Things That Go Bump in the Night.* Syracuse, NY: Syracuse University Press, 1959.

Jordan, Phil. *I Knew This Day Would Come: A Personal Journey to Psychic Self-Awareness.* New York: self-published, 1999.

Keller, Robert. Personal interview. July 21, 2010.

Kingman, LeRoy Wilson. "Owego: Some account of the settlement of the village in Tioga County, New York." www.archive.org/details/owegosomeaccount00king. 2007.

Martinichio, Father John. Personal interview. July 19, 2010.

McEnteer, Thomas C., ed. *Seasons of Change: An Updated History of Tioga County, New York.* Owego, NY: Tioga County Legislature, 1990.

Merton, Thomas. *The Seven Storey Mountain.* New York: Harcourt Brace, 1948.

Morgan, Henry Lewis. *League of the Iroquois.* Secaucus, NJ: Citadel Press, 1972.

Norkunas, Martha. *Monuments and Memory: History and Representation in Lowell, Massachusetts.* Washington, D.C.: Smithsonian Institution Press, 2002.

Penney, Darby, and Peter Stastny. *The Lives They Left Behind: Suitcases from a State Hospital Attic.* New York: Bellevue Press, 2009.

Reynolds, Nancy Barno, and Jim Ehmke, prods. *Binghamton Heals: Surviving the Tragedy at the Binghamton Civic Association.* 2010.

Richardson, Judith. *Possessions: The History and Uses of Haunting in the Hudson Valley.* Cambridge, MA: Harvard University Press, 2003.

Richter, Daniel K. *The Ordeal of the Longhouse: The Peoples of the Iroquois League in the Era of European Colonization.* Chapel Hill: University of North Carolina Press, 1992.

Rose, Nicole. Personal interview. July 14, 2010.

Seekings, Cara. *The Ladies of Lily Dale.* Lily Dale, NY: Lily Dale Assembly, 2010.

Serling, Rod. "The Hitchhiker." *The Twilight Zone,* season 1, episode 16. Twentieth Century Fox. 1996 [1960].

―――. "Walking Distance." *The Twilight Zone,* season 1, episode 5. Twentieth Century Fox, 1996 [1959].

Shakespeare, William. *Romeo and Juliet.* London: Penguin Classics, 2007 [1597].

Smith, Gerald R. *The Valley of Opportunity: A Pictorial History of the Greater Binghamton Area.* Norfolk, VA: Donning Company, 1988.

Tehanetorens. *Legends of the Iroquois.* Summertown, TN: Book Publishing Company, 1998.

Temple, Chris. "Real American Heroes: The Story of George F. Johnson." www.nationalinvestor.com/EJ%20story.htm. 2010.

Thompson, Stith. *Motif-Index of Folk-Literature.* Rev. ed., 6 vols. Bloomington: Indiana University Press, 1966.

Tucker, Elizabeth. "Ghosts in Mirrors: Reflections of the Self." *Journal of American Folklore* 118, no. 468 (2005): 186–203.

―――. *Haunted Halls: Ghostlore of American College Campuses.* Jackson: University Press of Mississippi, 2007.

Wagner, Stephen. "Phantom Phone Calls." paranormal.about.com/od/ trueghoststories/tp/phantom-phone.htm. 2011.

Wallace, Anthony F.C. "The Tuscaroras: Sixth Nation of the Iroquois Confederacy." *Proceedings of the American Philosophical Society* 93, no. 2 (1949): 159–65.

White, Maryanne. Personal interview. June 23, 2010.

Wicker, Christine. *Lily Dale: The True Story of the Town That Talks to the Dead.* San Francisco: Harper SanFrancisco, 2003.

Winfield, Mason. *Shadows of the Western Door: Haunted Sites and Ancient Mysteries of Upstate New York.* Buffalo: Western New York Wares, 1997.

Winfield, Mason, and Terry Fisher. *Phantom Tour: The Thirteen Most Haunted Places in Western New York.* Directed by Terry Fisher. Full Circle Studios, 2003.

ABOUT THE AUTHOR

Elizabeth Tucker is a professor of English at Binghamton University, where she teaches folklore. She has written two books about ghost stories: *Campus Legends* and *Haunted Halls: Ghostlore of American College Campuses.* She learned to tell stories as a Girl Scout in Washington, D.C., and as a Peace Corps volunteer in West Africa. One of her greatest joys is learning and telling ghost stories of upstate New York.

Visit us at
www.historypress.net